GEN ADM
ROW
ADM SEAT

ADVANCE
ADM $ 20

BUDWEISER

BACHELOB PRESENTS

SQUEEZE
RITZ, 119 E 11ST, NY
7:30

COLA CONCERT SERIES AT
THE B-52'S
PYLON
8:00P MON JUN 25
NO CAMS/REC/CANS/
22860398RE0440
RAIN OR S

JONES BEACH
DATE/EVENT CODE

ORCH

Q

D081I8999

THE R
PRESENT
THE
ENGLISH
11TH ST BETW
3RD & 4TH AVE
OCT

ND
SDAY
13

1128L
EVENT

PHOE
TIER
SEC
62
ROW/BOX
2
SEAT

CARNEGIE HALL

TRACY CHAPMAN
MON NOV 28, 1988 9:45PM

LOU REED
80's tour

G.A. GEN ADM
SECTION/BOX ROW SEAT
GENERAL ADM

ADVANCE
All Taxes Incl. If Applicable
ADM $ 12.50

G.A.
SECTION/BOX
GA 1X
GEN ADM
RTZ1753
A24MAR7

JOHN SCHER PRESENTS
SHRIEKBACK
THE RITZ, 119 E 11ST, NYC
DOORS 9:30PM/SHOW 11PM
16 YRS AND
SATURD

GE

TH

RADIO CITY MUSIC HALL
RADIO CITY MUSIC HALL
1260 AVE OF THE AMERICAS
THE TUBES & UTOPIA
FRIDAY EVENING
MAY 10, 1985 8:00PM

$17.50
$.00

16

WITH I.D

087

MEDIA ONE
PRESENTS

ARD JONES
SNITZER CONCERT HALL
PORTLAND, OR
1
9
8
5
TUESDAY
8:00 P.M.
LUDES 25¢ USER'S FEE

RE 1 MEZZ
1ST MEZZ LEFT
E 603

ORCH

SEC ROW
GEN. A
ADMIT ONE TH
AUG 4
BOTTOM LI
PRESENTS
STAN RIDGWAY
CINDY LEE
BERRYHILL

BEACON T
Z-100 F
SINEAD O'
FIRST PRIOR
NO REFUNDS/
8:00P TUE A

SIOUXSIE
AND THE
BANSHEES
The Scream!

OURCH

ORC

5.50

ADVNCE
All Taxes Incl. If Applicable
ADM $ 14.50

PRESENTS
REFUNDS
GR

THE PRETENDERS

ADULT
25.00

RESALE INVALIDATES TICKE
RADIO CITY MUSIC HALL
TROPICANA, NY'S #1 JUI
EURYTHMICS
MONDAY EVENING
13, 1989 8:00

MS0803
EVENT CODE

FIEL

AN EVENING WITH
TALKING HEADS
MILLETT HALL—OXFORD, OHIO
8
1
9
8
3
SATURDAY
SHOW BEGINS
PROMPTLY 8 PM
No opening act for this concert. No smoking—
everages—no refunds or exchanges—no resa

A230CT

MON16191

REDUX

REDUX

by
Mike Hipple

foreword by
Dave Holmes

Schiffer Publishing Ltd

4880 Lower Valley Road • Atglen, PA 19310

**Other Schiffer Books
on Related Subjects:**

*Put the Needle on the Record:
The 1980s at 45 Revolutions Per Minute*
Matthew Chojnacki
978-0-7643-3831-1

*VHS: Video Cover Art:
1980s to Early 1990s*
Thomas "The Dude Designs" Hodge
978-0-7643-4867-9

Copyright © 2018 by Mike Hipple

Library of Congress Control Number: 2017953852

All rights reserved. No part of this work may be reproduced or used in any form or by any means—graphic, electronic, or mechanical, including photocopying or information storage and retrieval systems—without written permission from the publisher.

The scanning, uploading, and distribution of this book or any part thereof via the Internet or any other means without the permission of the publisher is illegal and punishable by law. Please purchase only authorized editions and do not participate in or encourage the electronic piracy of copyrighted materials.

"Schiffer," "Schiffer Publishing, Ltd.," and the pen and inkwell logo are registered trademarks of Schiffer Publishing, Ltd.

Designed by Matthew Goodman
Type set in Post Grotesk & Antenna Comp

ISBN: 978-0-7643-5496-0
Printed in China

Published by Schiffer Publishing, Ltd.
4880 Lower Valley Road
Atglen, PA 19310
Phone: (610) 593-1777; Fax: (610) 593-2002
E-mail: Info@schifferbooks.com
Web: www.schifferbooks.com

For our complete selection of fine books on this and related subjects, please visit our website at www.schifferbooks.com. You may also write for a free catalog.

Schiffer Publishing's titles are available at special discounts for bulk purchases for sales promotions or premiums. Special editions, including personalized covers, corporate imprints, and excerpts, can be created in large quantities for special needs. For more information, contact the publisher.

We are always looking for people to write books on new and related subjects. If you have an idea for a book, please contact us at proposals@schifferbooks.com.

for Sam, Robert, and Hillary

Contents

Foreword by Dave Holmes

We remember the 1980s as a time of bold, dayglow colors. But for some of the kids of the time, the era could be pretty gray. It was an age of conformity, of conservatism, of winners and losers and nothing in between. It was not yet cool to declare oneself a nerd. To have an interest in music was fine, but too much interest made you suspect. To obsess over anything that wasn't sports or stocks was weird. It made you an outsider, and not even C. Thomas Howell wanted to be an outsider.

I was an outsider. I obsessed over music the way normal kids obsessed over football, and in the end, I am so glad I did. Because in the early 1980s, a new sound began to pulse out of my speakers. A sound that was fresh, arty, synth-y. A sound that spoke to me, because not only did it freak out my parents, it freaked out my older siblings.

It was what we were beginning to call "alternative music," an umbrella term for whatever wasn't getting played on Top 40 radio, and it aimed itself right at us outsiders. Once in a while, a band would break through, and you'd thrill as the world found out about The Cure. Sometimes the popular kids would co-opt a song, as they did with "I Melt With You." And sometimes you'd pick up on the messages the other outsiders were sending each other, like when we saw "THE RAVE-UPS" scrawled across Molly Ringwald's Trapper Keeper in *Sixteen Candles*.

Sure, the cool crowd had their Van Halen and their Bon Jovi, and that's all fine, but did it inspire them to do anything but drink beer and have sex? Even to know about a band called Orchestral Manoeuvres in the Dark felt subversive to a kid in the early 80s, but to consider that some other outsider knew about them—maybe even in your own town, *maybe even in your own school*—was a thrill. It made you want to find those people. It made you feel like you could build your own community. So we sent up flares, through mix tapes, through skinny ties, through little tiny buttons with the 2-Tone guy on them. And we found each other. The alternative music of the 1980s made us want to keep going. It said: *keep writing, keep playing guitar, keep getting on*

stage. There is a world out there for you. It may never have said it directly—maybe it got its point across with a synth tone, a poetic lyric, a bold haircut—but the message was received loud and clear, and with the magic of auto-reverse, the message played over and over again. For me, the slightly-left-of-center music of the 80s provided a window out of a dull gray life of bankers and baseball scores, and through that window I could see a world of color. This music affected a lot of us that way. We kept going. And a lot of us figured out what Mike shows us here: If you love this music enough, if you sit close enough to the stereo, eventually the speaker will open up and invite you in. If you move a step closer to the thing you love—literature, fashion, photography—that thing moves two steps closer to you. You will get to climb right into that world of color. You get to enter a world of artists and makers and doers. You get to live in the community you dreamed of, but it's better than you dreamed, because you made it yourself.

Mike was called to the world of photography. I started writing. And our obsessive natures, fueled by this strange, beautiful music, powered us into the lives we live now, where we get to mix with more of our kind. It drove us toward our people, toward a world where we are no longer outsiders.

It led us to a world where we can mix with the people who drew us in. We can actually meet Dave Wakeling. We can have an interview with Martha Davis. The people who inspired us in our youth are still making art, and now they're the people in our neighborhood. *80s Redux* shows us the artists who made the music that made Mike Hipple—and me, and you—the people we are today, as they are now. They've changed a little bit. So have we. But the truth stays the same: music can change your life, if you let it.

May it continue to do that for generations of weird, wonderful kids to come.

–Dave Holmes

Dave
Wakeling

When The Beat (The English Beat in the U.S.) broke up in 1983, singer Dave Wakeling landed in America, where the band's fortune was rising just as it was beginning to decline in the U.K. Although the band's three albums had produced hit after hit ("Can't Get Used to Losing You," "Mirror in the Bathroom," "I Confess," and "Save It for Later"), a fourth LP was not in the cards. Instead, Wakeling found success with General Public, a new band he formed with The Beat's Ranking Roger. Their song "Tenderness" became a Top 40 hit.

Wakeling arrived in southern California in the early 90s to record a solo record and never left. "California was all the Beach Boy dreams I had as a kid," he tells me.

Soon, he had his own children and a job with Greenpeace that allowed him the time to be a dad. He wanted to be home for his kids so he "could be Coach Dave on the soccer team or the dad who could really help with the algebra, that sort of thing," he says.

He would do some gigs around his home base of L.A., but nothing too far until his kids got a bit older.

"By the time the kids got to be teenagers, it gave me the opportunity to start branching out a bit, he says. "I slowly started developing the West Coast a bit, then the following year out to the East Coast and that went fantastic. Now, I'm up to about 160–170 shows a year all over the States, Canada, Australia, New Zealand, and England."

His shows are generally sold-out affairs, with fans enjoying all of his old hits. I ask if he likes playing his old songs: "Oh yes, because they're not 'old' songs to me. The lyrics still sometimes mean the same thing, but they've often taken on more subtle and nuanced meanings as we get a few extra decades to taste love and life and grief and loss. To me, they're not old songs because the meaning changes in subtle and sometimes hilarious ways . . . It's interesting to watch the history of my emotions through my songs."

Over the last few years, he's introduced several new songs into the mix and found that fans were hungry to get their hands on them. He launched a PledgeMusic campaign that allowed him to record a new album. After that album's release, he's planning on taking some of the thirty songs that didn't make the final cut and possibly releasing them on an EP.

"I don't think I'll go for the huge dramatic, *ta-dah!* album. I don't think my fans actually need to wait five or six years for another album, when I could release two or three songs a year. If people like the record, I'd like to follow it up with a two- or three-track EP. Those were my favorites. Some people were a singles guy or an album person, but I was an EP guy. Four songs on a single? Fantastic!"

Martha Davis

Upon entering the main room of Martha Davis's 100-year-old farmhouse, located between Portland and the Pacific coast, I immediately get a distinct Stevie Nicks-witchiness vibe: turn of the nineteenth-century spectacles sit next to a skull, magnificent old globes, and a tapestry with a 1950s-era postcard image of Mount Hood. Shelves along the walls are lined with science and art books.

Martha breezes into the room a little bit later explaining how she's not used to getting ready for photo shoots. The first thing I notice is that unmistakable rich and velvety voice, one of the more iconic voices from the 80s. When I ask about when she discovered she had such a voice, she tells me it's not something she knew she had in her.

"I'm a writer not a singer, I never thought of 'my voice' but just knew I wanted to tell stories . . . and if Dylan can do it? We listen to voices not just to soothe us but to excite and disturb us—Lou Reed, David Byrne, Tom Waits. My voice is not as dramatic, wish it was. I guess people like it . . . but I sure as hell have never worked on my voice or made that the vehicle. It's about the stories."

And Davis has a lot of stories. She could easily fill an autobiography with all the fascinating twists and turns her life has taken. She grew up in the Bay Area, got pregnant at 15, and found herself an Air Force wife in Florida—far from happy. After her mother committed suicide, she found a diary in which her mother lamented the trade-offs she had made in order to please her husband and stay within the social norms. Martha saw this as a sign that she had to go and live her dreams of a music career. So, in 1975, she did just that. She left the Bay Area, where she had returned after divorcing her husband, and headed to Los Angeles. She was a single mother of two young children and rock was hardly a younger person's world, but that didn't stop her. She was almost 30 when "Only the Lonely" broke in 1982. Other hits followed and, although The Motels would still get together in different forms over the years to record more music, by the late 80s, Martha had gone solo.

Martha eventually drifted her way northward to Oregon. She tells me this has always been more her vibe—she was always taking in the stray cats and pets and imagined herself someday in the country surrounded by her animals. And, that is exactly where she is.

"My life and career have been wonderful—from high points to low, as it should be. We all struggle through the thick of it . . . and try to make something beautiful of life."

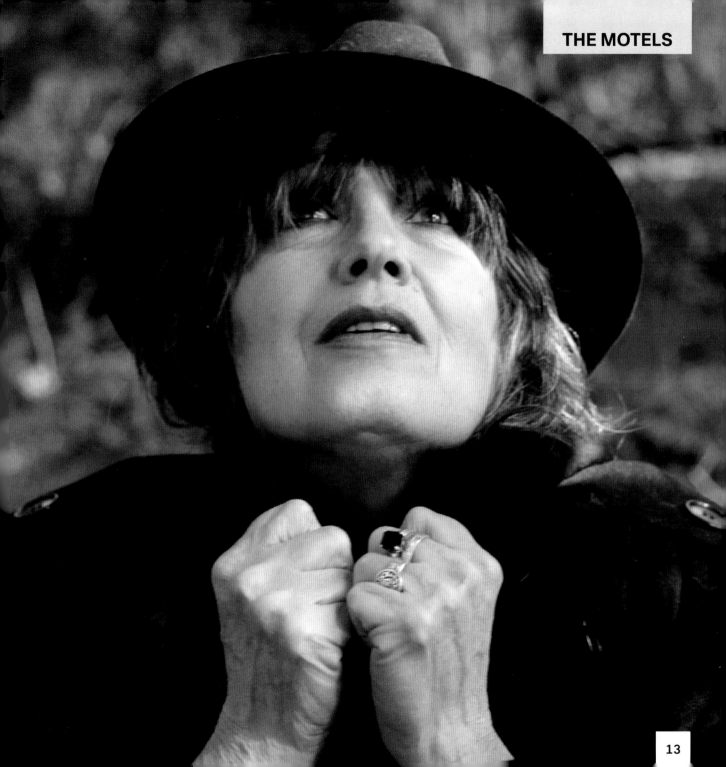

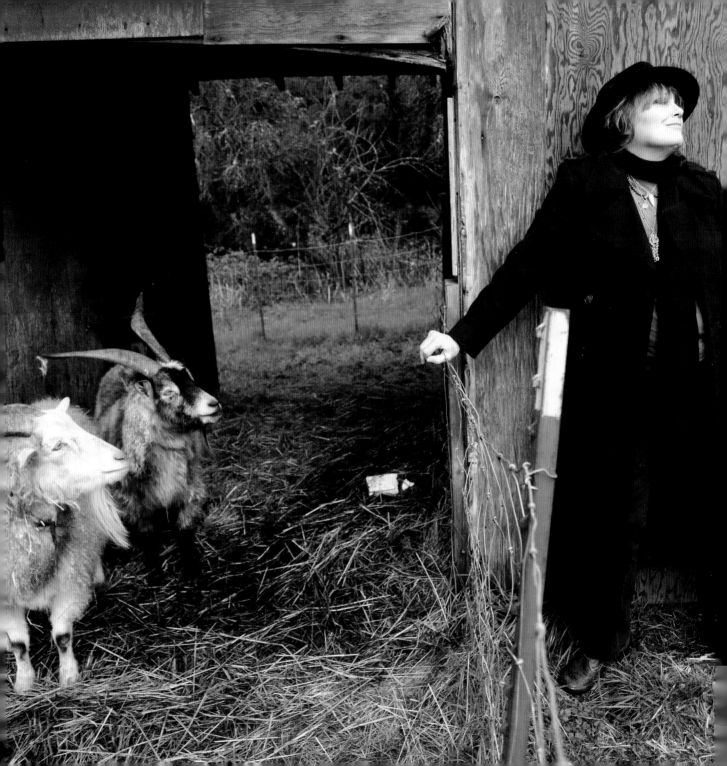

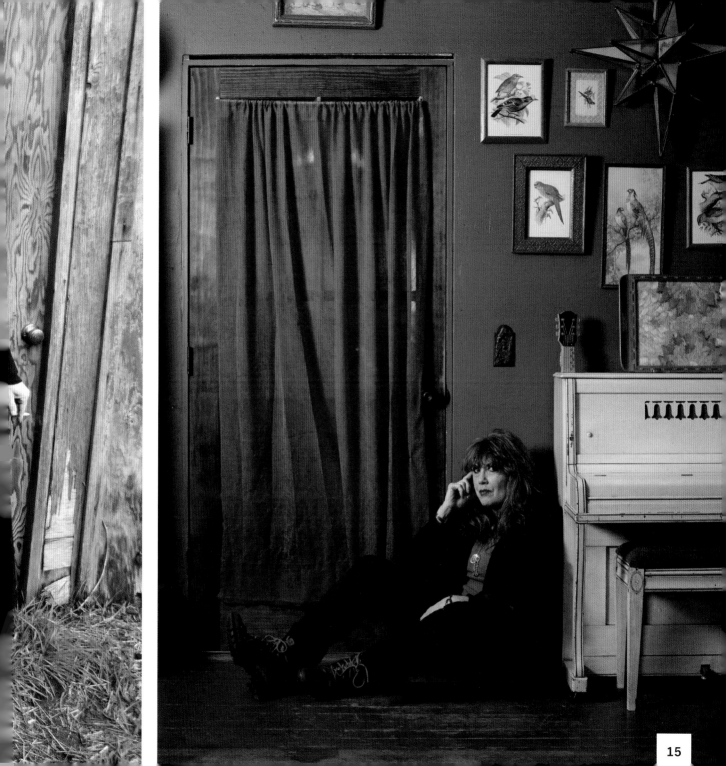

Michael Aston

Gene Loves Jezebel founder Michael Aston still loves touring. I met up with him a day before he performed in an 80s revival show.

"Touring is better when you're older because there's no pressure of the label, no thousands of photos and interviews, radio station visits," Michael says. "Now, you go there, have the sound check, have a beer, you play a show, meet a lot of old friends. It's a joy."

Growing up in a small steel town in Wales, all he wanted was to get out. "When I was ten or twelve, I only wanted to be a rock-and-roll star. What a great life they have, jumping on planes, seeing the world. America felt like another planet."

That dream was achieved when Aston and his twin brother Jay formed Gene Loves Jezebel in the early 80s. Their gothic dance sound found heavy rotation on college and underground radio stations across America, spawning their biggest hit, "Desire," in 1985. But, a creative fall out between the brothers led to a split. Michael wanted to be more artistically adventurous, make quirkier music. He went on to record his own music and enjoyed the creative freedom of being a solo artist. Breaking from Gene Loves Jezebel, "released me because I feel so confident in my own abilities now," he says. "I've had to learn to do it on my own."

Now, when he's not touring or painting, he feels like he's in a great place with a great family and still gets the chance to be a rock star—the best of both worlds. As he continues to tour the 80s circuit and play clubs high-lighting his newer music, he's heartened by the many young folks he sees in the audience.

"This younger generation, which I think is amazing, they listen to everything. They're really aware. They love Joy Division, The Cure, Jane's Addiction. I remember when I was in my early twenties, I started listening to the more obscure music too. It doesn't change does it?"

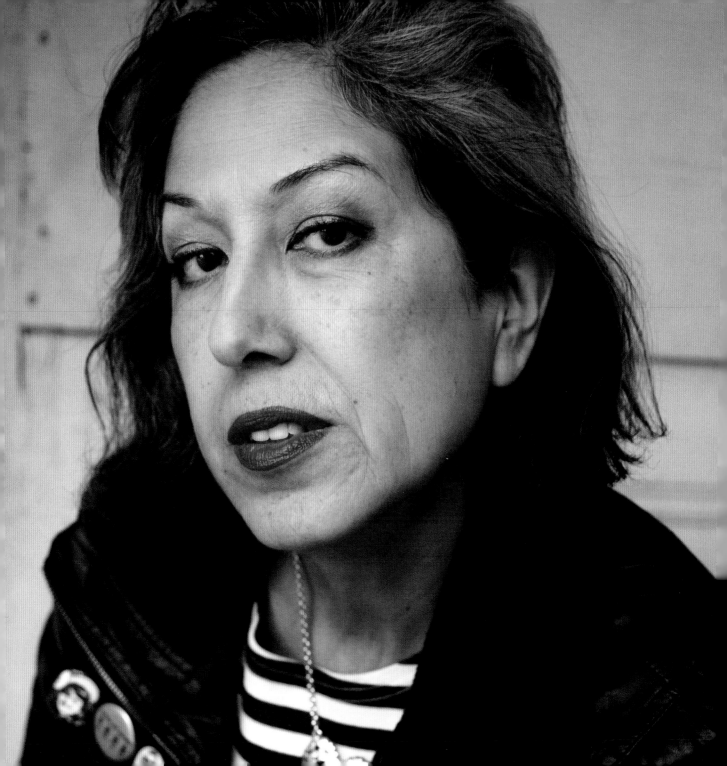

Alice Bag

Alice Bag was on the forefront of the L.A. punk scene when she formed Alice and the Bags in the late 1970s. They did not release a lot of material in their heyday, but their history would help pave the way for other female and minority artists. Her influence on the music scene and the barriers through which she broke as a feminist, Latina front woman of a hardcore punk band is criminally underrated.

"Punk means so many things to me. It means challenging the status quo with humor, with music, with political action. It's understanding what it means to be part of a community. It's rejecting standards of competency that limit the quantity and diversity of voices that can be heard."

Nowadays, I've come to see Alice Bag as an archivist of the early Los Angeles punk scene. She's been meticulously recording the stories of the women who were trailblazing their way through this burgeoning music scene in the 80s—women like Penelope Houston, Allison Anders, and Dinah Cancer.

"I'm interested in preserving women's stories of the early L.A. punk scene. I try to interview women who were involved in the early scene because their stories were being ignored. Books and articles were being written about punk and they seemed to focus on males, particularly white males. The L.A. scene was much more diverse and inclusive than that. It bothered me that our scene was being misrepresented and that so many people who helped shape it were being left out, so I decided to do something about it. I asked women to share their stories, photos, and memories on my website."

Bag released her first solo record in 2016 and has also written a memoir of her youth titled *Violence Girl*.

"I'm even more passionate about music now. I've grown as a writer. I'm smarter and more self-confident than when I was a teen. I was passionate then but I was a sort of wildfire; I burn with intent these days."

Ozn

MTV played "AEIOU Sometimes Y" all the time in the early 80s and I remember thinking, *What is this? Is it singing? Talking? Sing-talking?*

Robert Rosen, the "Ozn" half of the duo (who legally changed his name to Ozn) explains, "Austin Texas producer Jay Aaron Podolnick introduced EBN and I and it was creative love at first sight. EBN loved my rap tape and I loved his cutting edge electronica. Turned out we were both brought up four blocks away from each other in Greenwich Village and we'd never met. He played me the beginnings of a Kraftwerk-influenced track and I immediately riffed this spoken word rap over it, telling a story of a Swedish girl I'd recently met across the street from Lincoln Center and he just went, 'That's perfect it's perfect!' And 'AEIOU Sometimes Y' was born. Crazy that within minutes of the first meeting we wrote a song that turned into our first record that got us a record deal before we even named the duo. It was creative magic, truly."

Ozn jokes that he was, "the first white rapper," and clarifies, "just to be clear, while I'm sure I was one of the first—I made my first rap demo in 1980/81, my first major label release in 1983—I don't exactly know who *the* first was . . . I discovered rap walking down the street because in certain areas of Manhattan, rap was constantly blasting out of storefronts and apartment windows. I fell in love with it instantly. As a most bohemian New Yorker and as a trained stage actor and singer, working in rap was so natural for me, such a no-brainer that I just assumed artists of all colors were on it because it was so fresh and exciting. It never dawned on me that I was doing something unique until I attempted to shop the tape. White record executives thought I was absolutely shit-for-brains bonkers to be making rap records."

Shortly after the success of that song, Ēbn-Ōzn broke up. Ozn couldn't get another record deal and decided to go it alone, starting an indie dance label called One Voice. He never spoke much about it at the time as he felt somewhat ashamed that people would think the only reason he started the label was because no major label would have him. At the end of the 80s, he topped the dance charts as DaDa NaDa with the song, "Haunted House" and "Deep Love." In 2015, he recorded his first song in 25 years, "Je Suis Paris!" in support of peace after the Charlie Hebdo shootings. He later re-recorded the track as "I Am Orlando" after the Pulse nightclub shootings.

This time around, he's not ashamed of releasing his music on his own terms.

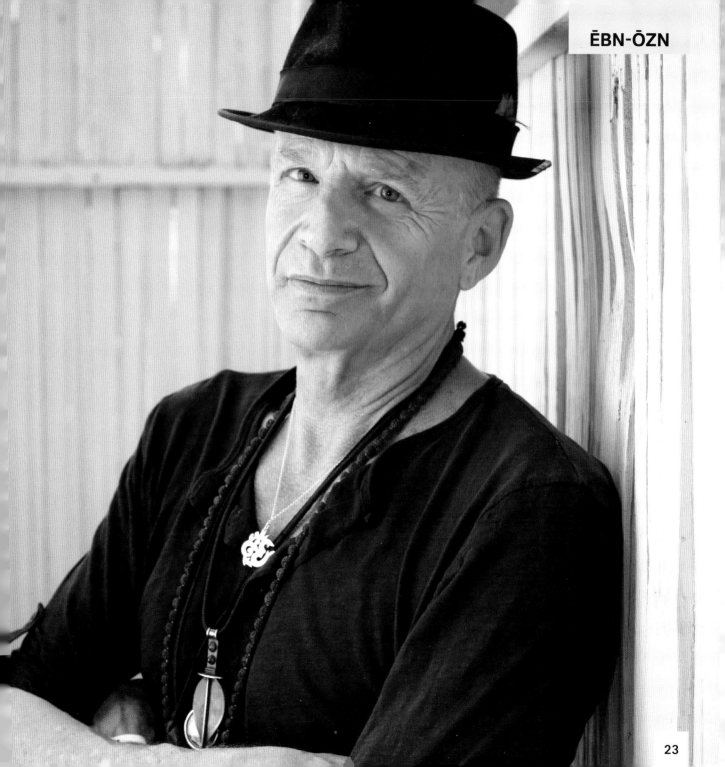

Valerie Day
& John Smith

"I Can't Wait" from Nu Shooz was everywhere in 1986. If you turned on the radio, there it was. To some degree, this is still true today—there's even a fairly faithful version by Icona Pop and Questlove that has made the rounds recently.

What is it about this song that made it such a success? Singer Valerie Day explains, "We did feel that 'I Can't Wait' sounded the most authentic of the songs we were recording at the time. We're still proud of it, and it still sounds great next to everything else on the radio. A lot of people contributed to its success. After all these years you'd think the thrill [of hearing it on the radio] would wear off. But now, when we hear it unexpectedly on the air, in the grocery store, or on TV, it's like hearing from an old friend."

After that initial rush of success, the follow-up was a long time coming and did not reach the same level of success. Cofounder John Smith tells me, "Well, to be perfectly honest, we spent too long making the second record, *Told U So*. There were a lot of reasons for that, but there was no pressure from the record company. Maybe sometimes too much artistic freedom is a bad thing. I don't know. I do know that we never attempted to make another song like 'I Can't Wait.' If

I had it to do all over . . . who knows? If we had a time machine, I could definitely tell that young man a few things about the music business that he didn't know. Would he listen? Probably not."

In person, John and singer Valerie Day are a happy and relaxed couple, their enthusiasm for their music is brightly evident. They've been doing this together for close to forty years. After the hits slowed down, John composed music for advertising agencies and films and Valerie taught voice. Together they raised a son. They're currently based out of Portland, Oregon, Valerie's hometown and the place they met and started the band.

Nowadays, the band has returned to its R&B roots, having released a new collection of songs titled *Bagtown* with a full band. They also still tour the 80s circuit as a duo.

Singer Valerie Day tells me, "As for what the future holds, at this point we don't even try to predict! We never thought we'd be out there playing as Nu Shooz again. We've got a great band and released our first album of original Nu Shooz music in over twenty-five years—an organic funk/soul party record called *Bagtown*. The gigs are fun. The audiences are warm and welcoming. We're grateful to have the life we lead now."

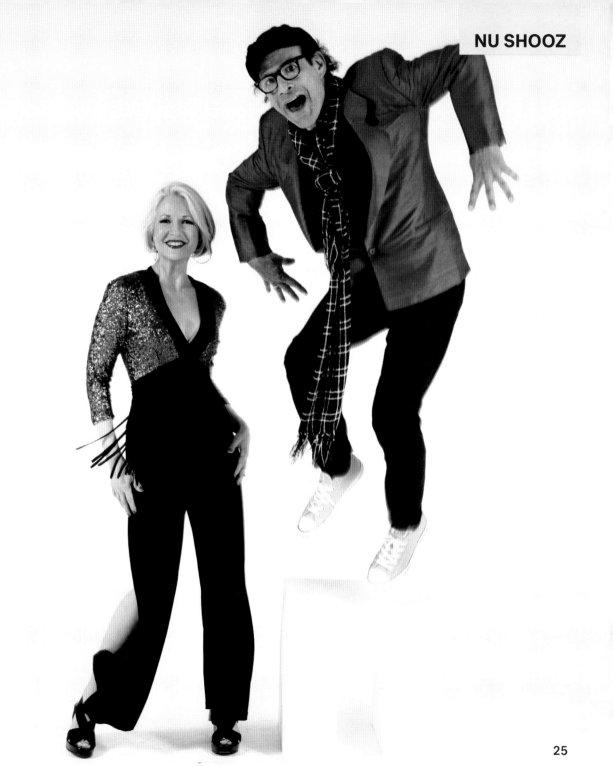

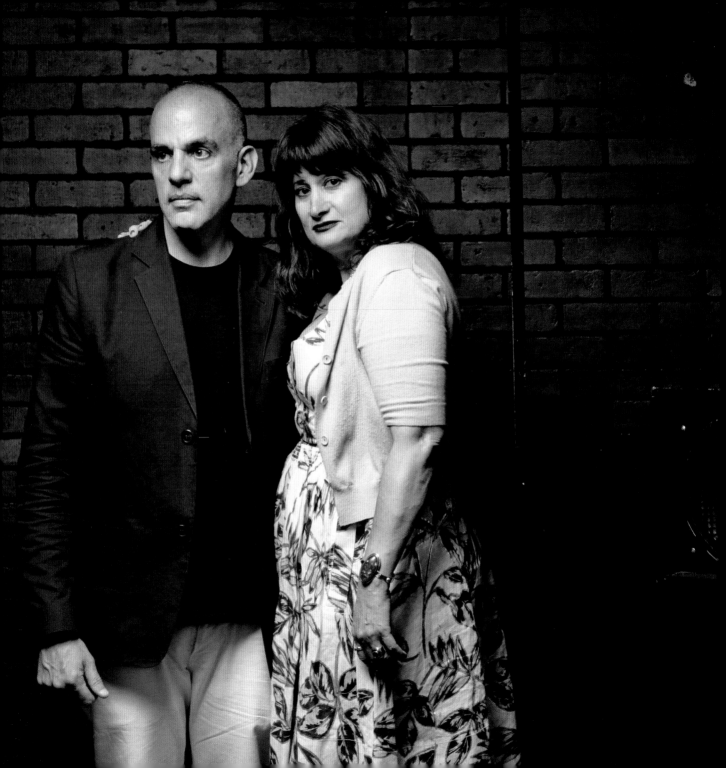

Ted Ottaviano & Susan Ottaviano

I still remember seeing Book of Love perform live in 1989 at The Ritz in New York City. I thought I was the coolest person ever, out in New York City with my friends, hanging out at this club I had heard about on MTV. Keyboardist Lauren Roselli came dancing out into the audience after the show. She grabbed my hands, did a little whirl with me, and she was off.

Book of Love grew out of New York's club scene in the 80s. They gained attention when Roselli gave DJ Ivan Ivan one of their early demos. Soon after, their classic hits "Boy" and "I Touch Roses" were unleashed upon the world. Tours with Depeche Mode and more albums followed in quick succession and Book of Love developed a loyal following. You couldn't go into a club in those days without hearing "I Touch Roses."

By 1994, the band took a break. Singer Susan Ottaviano began working as a food stylist on photo shoots. Roselli was acting in movies and dabbling in music. Jade Lee went into graphic design. Ted Ottaviano continued to make music with a studio project called The Myrmidons (with Roselli) while also creating music technology courses, which he taught in a number of schools.

In 2016, the band celebrated the thirtieth anniversary of the release of their debut album with a couple of shows and a new best-of collection, which included new songs "Something Good" and the stellar "All Girl Band." 2016 also saw the passing of one of Ted's musical heroes, David Bowie, who inspired him to create new music with Book of Love. "He was a northern star for me. His last years were creatively potent again and a major inspiration to move forward."

For Ted, music is still a passion. "It's important to follow your bliss which sometimes leads you to places that you don't expect."

Lol Tolhurst

Robert Smith is clearly the front man (and most recognizable face) of The Cure. But it takes more than one person to make a band. Lol Tolhurst has known Robert Smith since they were five years old and, together, they launched the band that grew to provide the soundtrack to the lives of so many teens in the 80s. However, by the time they began recording *Disintegration*, Lol had developed substance abuse issues and left the band.

"We were very young when we became successful. Most of my fame comes from before I was thirty years old! I don't think as young men we were equipped to deal with the destructive tendencies we had and view things in a more compassionate way with each other. Simon [Simon Gallup of The Cure] said to me recently that his one regret was that 'we weren't kinder to each other when we were younger.' Very true and wise observation."

Lol has since overcome his demons and relocated to the sunnier shores of southern California. Aside from focusing on the duties of a stay-at-home dad, he's also recorded solo music with his wife and written a memoir of his time with The Cure entitled *Cured: The Tale of Two Imaginary Boys*. The book has been a success and Tolhurst has been touring the country hosting readings and signings. Writing will definitely continue to be a part of his future. "I always felt like a writer," he says. "I wrote lyrics in The Cure and always read my whole life. It's a passion for me."

Of course, he will forever be tied with The Cure. "[They're] all the people I grew up with. The people that were with me in my teens, which is a very important time. We will always be family. Always."

As for his legacy, Tolhurst says, "I hope that we were able, as The Cure, to show people that there's a different way to be in this world, that you can be an outsider and still have validity in your life. A value that's your own. That would make me happy."

Yes, Mr. Tolhurst, I think you have succeeded more than you know!

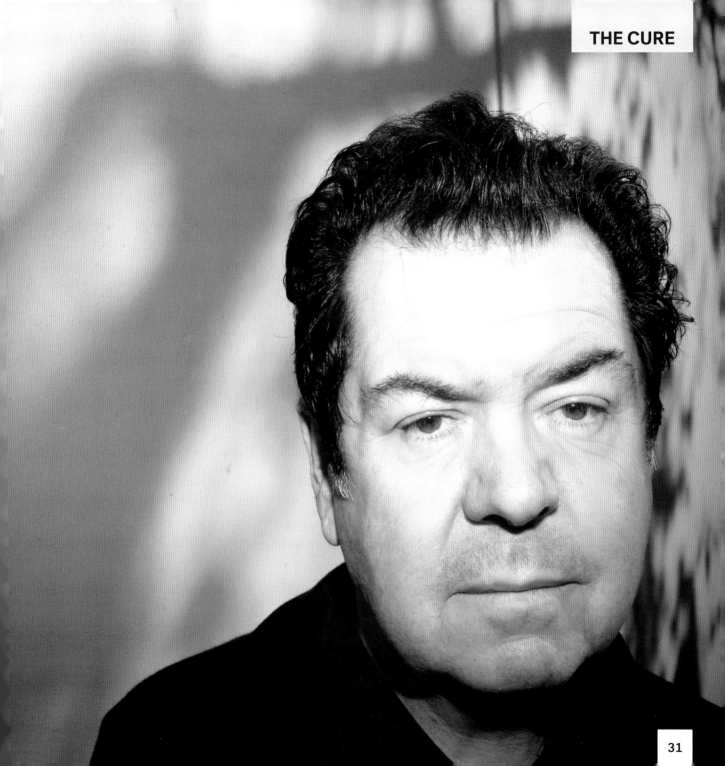

Fishbone

Fishbone arose in southern California out of the conservative political climate of the early 1980s. They fused social commentary on top of funk, ska, and punk grooves and released tracks like "Freddie's Dead" and "Party at Ground Zero," which my local college radio station played every Friday at 5:00 PM heading into the weekend.

Their politics still intact, they see music being used as a wake-up call as much in today's political climate as it was in the early 80s. Famously, their song "Lyin' Ass Bitch" was used as the intro music when then-Presidential candidate Michele Bachmann was on *The Tonight Show*, and the band has also dedicated the song to Trump in recent performances.

Their live shows were essentially parties and that party vibe extends to the touring they do today. When it comes to giving it their all in their live performances, age has not slowed them down in the slightest.

When not working with Fishbone, frontman Angelo Moore stays busy working on a variety of projects, including releasing several solo albums and working on Project N-fidelikah with members of Dokken and War.

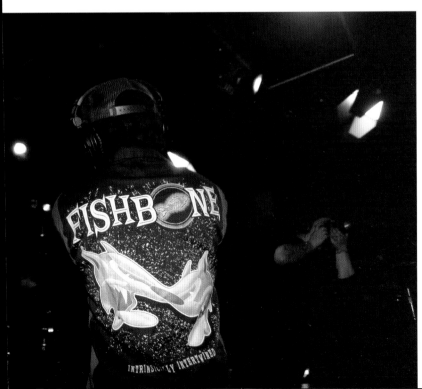

Dean Wareham

Galaxie 500 only released three albums, all towards the end of the decade, but their sound was one of the first to inch into the "indie rock" territory that would become de rigueur in the 90s.

Singer-songwriter Dean Wareham tells me, "I feel like Galaxie 500 wasn't a part of the 80s in a way. The records don't sound 80s. They don't sound 90s either," he laughs. "I guess often what you're doing is a reaction to what has just come before. That was a time when people were turning against the 80s sounds and turning back to try and make things maybe sound a bit more natural."

Galaxie 500 broke up in 1991, and Wareham went on to form the band Luna. When Luna disbanded in 2005, Wareham, together with his wife, Britta Phillips, worked on film scores for several Noah Baumbach films (*The Squid and the Whale* and *Mistress America*) and formed a band called Dean & Britta that has released three records to date.

In 2008, they worked together on a project for the Andy Warhol Museum, writing songs and performing them live in front of some of Warhol's screen tests, basically four-minute filmed portraits. They ended up touring the world with this performance. "You don't say no to Andy Warhol!"

"I'm still eking out an existence as a musician. Lots of people take the angle that the Internet has destroyed everything for musicians. I think it was always hard," he says. "Things keep changing. That's the first thing you learn about the music industry."

He's also toured with the Galaxie 500 songs, as well as a re-formed Luna. "Being away from it and coming back, you're more appreciative of the fact that you're out there on a Tuesday night playing and people could be at home watching TV or something, but they've chosen to spend money and come see your band play."

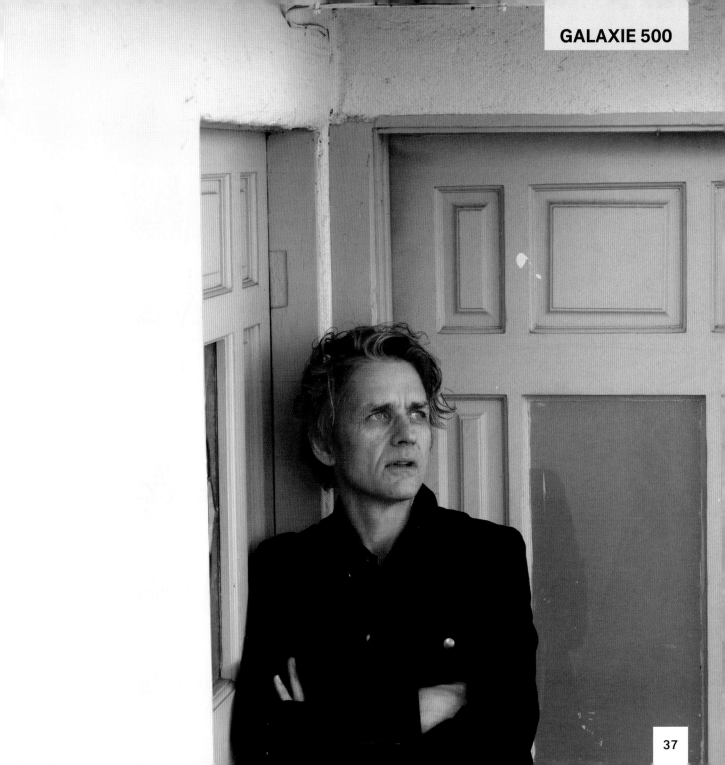

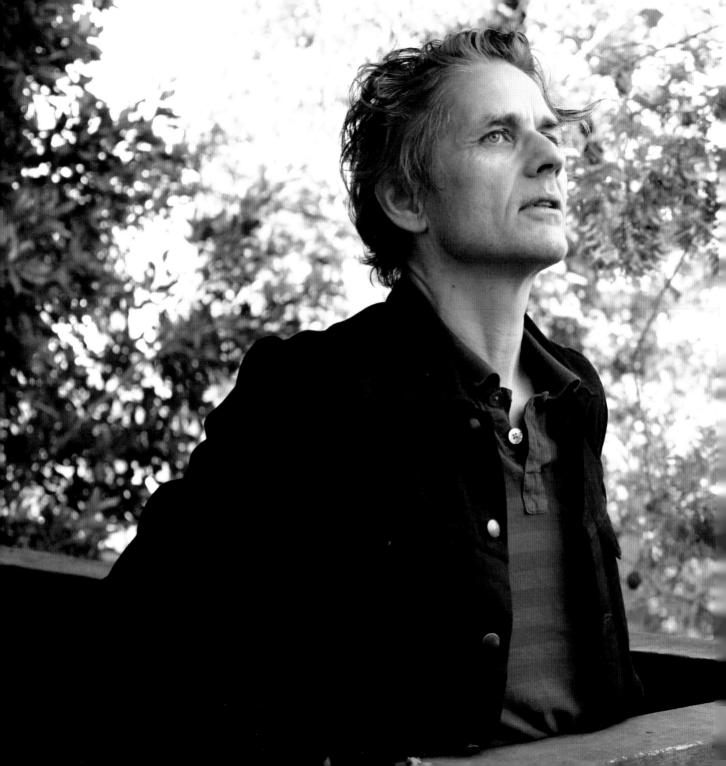

Debora Iyall

"I saw Penelope Houston playing in a club, and I thought to myself, 'Well, I have something to say, I can do this,'" Debora Iyall tells me. And, just like that, Romeo Void was born, releasing stellar singles like "Never Say Never" and "A Girl in Trouble (Is a Temporary Thing)." Their songs felt political and personal, even to my naïve teenage ears.

The band burned brightly but flickered out by the mid-80s. Between 1986 and 2008, they pretty much stopped recording altogether. Iyall had given up music and decided to study printmaking, eventually opening her own printmaking studio. In 1997, she began teaching art and printmaking to adults in San Francisco after receiving a grant that allowed her to work with Native Americans in recovery. She later taught art to at-risk kids and at continuation schools through artist residencies. It's clear that giving people a way to express themselves is important to her. "I like to be a community artist and I like to be of use," she says. "I think learning printmaking and having that workshop environment of we're all together at the time of each other's creations affected me. I thought that was a very powerful thing. You're witness to this cool thing that they made happen from nothing. A little bit of instruction and some art materials and bam, look what happened."

By 2007, she had relocated up to Portland, Oregon, to get her teaching accreditation. She taught at schools in the Navajo Nation for a while and eventually located to the desert outside Palm Springs, where she teaches today. She speaks with passion about her newfound teaching career. It's obvious she cares deeply about her students and their educational growth.

For Iyall, art, printmaking, and music are safe ways for her to reveal herself to the world. "In my creative process, what I want to say isn't always revealed at the beginning of the project, but it comes up as you're working on it. And, when you start feeling uncomfortable, that's probably your vein and you have to move in that direction."

As far as music is concerned, Iyall is planning on doing some new recordings with her band DIG, as well as re-recording some songs from her long-lost solo album, *Strange Language*.

"I'm planning creative work in the future, and I plan on teaching until I physically can't anymore. Teaching is this great gift I got later in my life—to have something that engages my mind and gives me pleasure. It nourishes me."

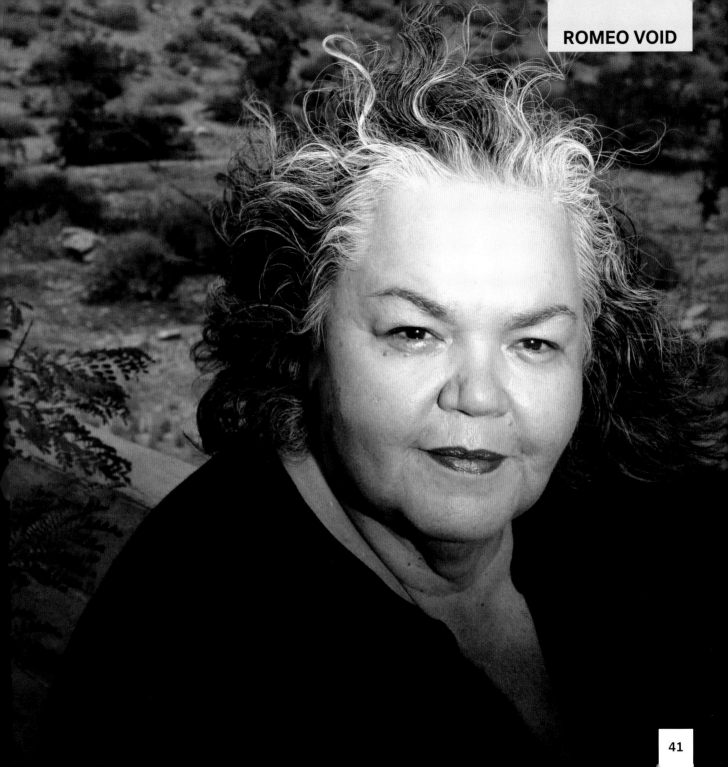

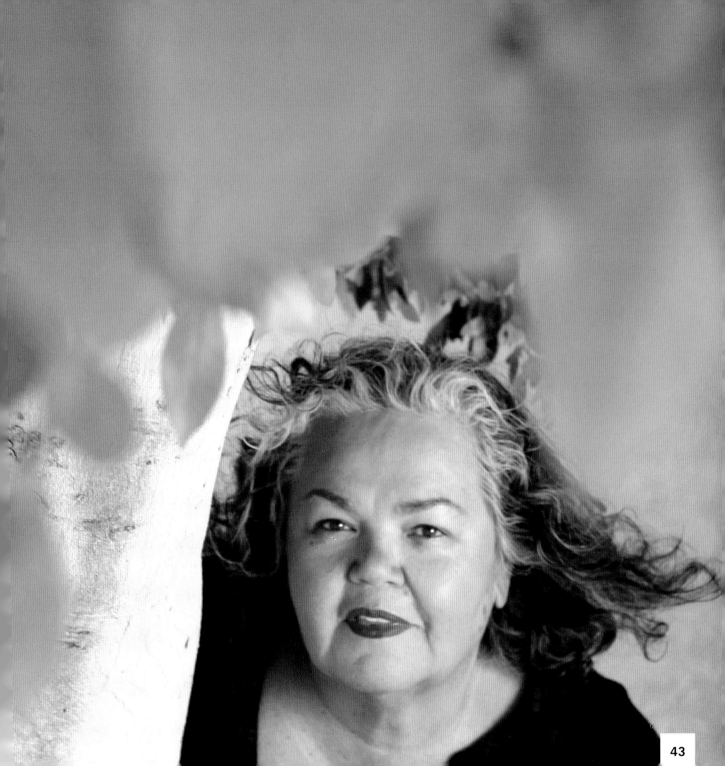

Rose McDowall

In one of our e-mail exchanges, Strawberry Switchblade's Rose McDowall asks me if I've seen the movie *Blow-Up*. She wants to do our photo shoot in the park in London where they filmed the scene where the dead body was found. "Oh, and I'm going to bring my crossbow, is that all right?" she asks. I wonder for a moment if this is really the Rose McDowall of "Since Yesterday" fame—or, if this is some strange plot to murder me in a remote park on the outskirts of London. After all, I had only exchanged e-mails with McDowall and there is no real way of knowing who you're dealing with on the Internet! Thankfully, it was actually her and I did survive the photo shoot.

Strawberry Switchblade was a chart-topper for a spell, with hits like "Since Yesterday," "Let Her Go," and a cover of Dolly Parton's "Jolene." Tensions within the band ultimately ended it and McDowall went on to record several solo songs that, up until recently, had never been released. She also collaborated with a wide variety of people, including Current 93, Psychic TV, and a young Björk.

Today, McDowall is still out there touring behind some of the re-issues and supporting what she calls her "dark folk songs." And, while she does have a collection of guns and weapons like the ones she brought to our shoot, she tells me with a chuckle, "I'm not at all a gun person to be honest. I just like to collect 'em!"

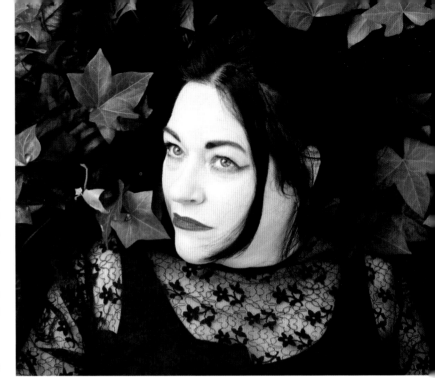

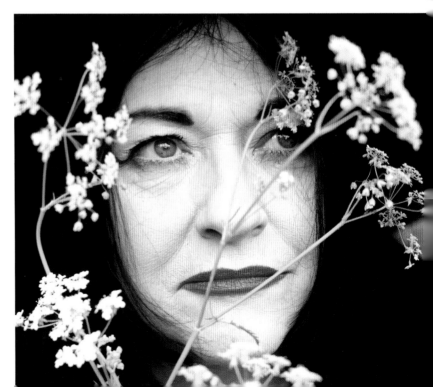

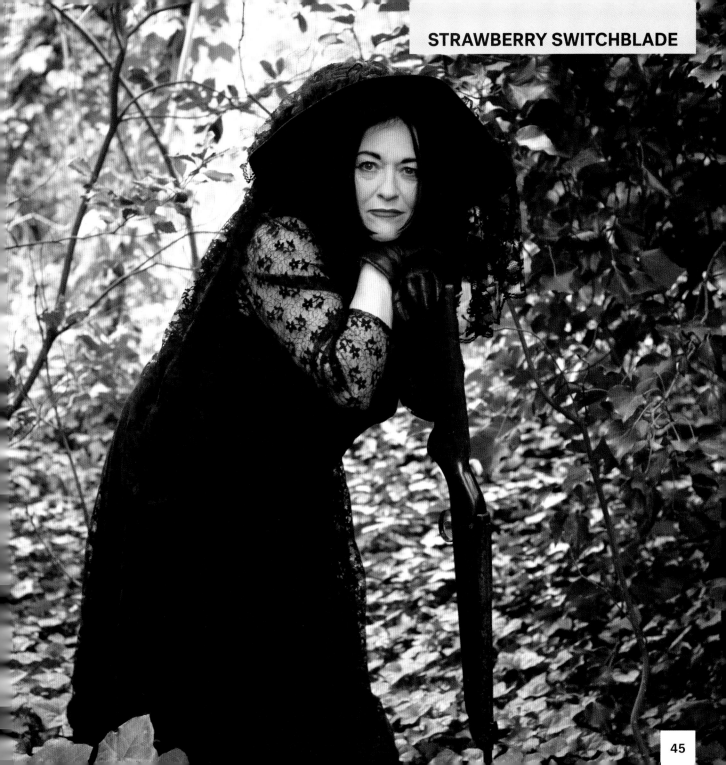

Marshall Crenshaw

Marshall Crenshaw's hooky and expertly played pop songs (and maybe the glasses, too) brought many critics to liken him to a latter-day Buddy Holly, an icon he actually portrayed in the 1987 film *La Bamba*. He scored a major hit in 1982 with "Someday, Someway" and another hit in 1983 with "Whenever You're On My Mind."

These days, you'll still find Crenshaw out on the road: "I've mostly been on the same path since the start: playing shows, making an occasional record."

He also hosts *The Bottomless Pit*, a radio show on New York's WFUV where he brings his favorite records from home and plays them for his audience.

He's not writing songs as often as he used to, though he did write a Golden Globe-nominated song for the 2007 film *Walk Hard*. Instead, much of Crenshaw's creative energy is spent on a documentary about legendary record producer Tom Wilson. "If I ever get to the end of the trail with that, maybe I'll write some more songs then, record some more," he says. "I still love doing it when I do it."

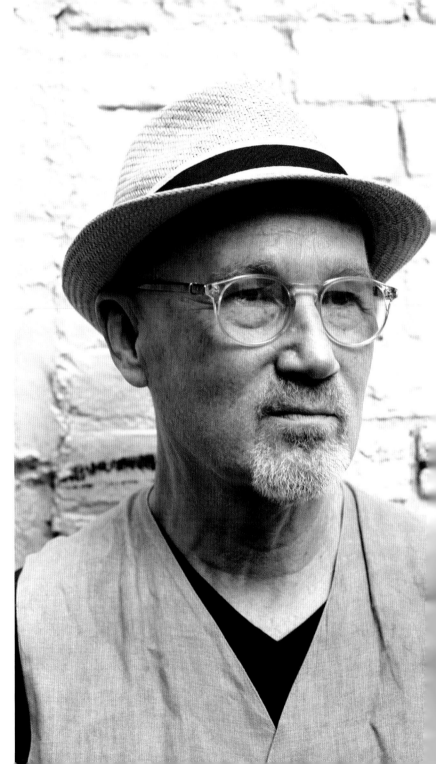

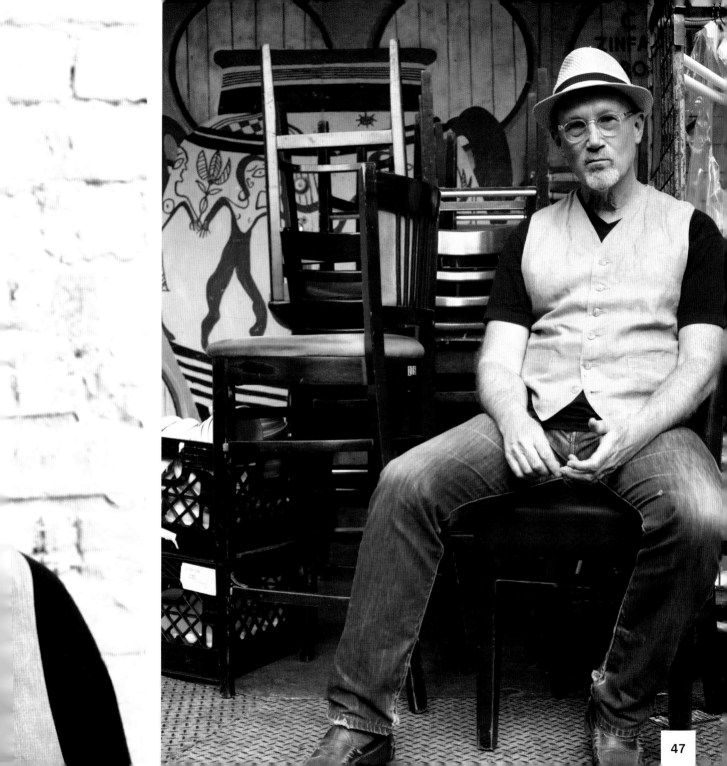

J.J. Fad

"We're J.J. Fad and we're here to rock!"

And with those words from their massive hit, "Supersonic," J.J. Fad went down in history to become the first female rap group to go platinum and be nominated for a Grammy.

Juana Sperling (aka MC J.B.) tells me, "We definitely feel like we are trailblazers for the female rap game. During our time, rap was very much a male dominated genre, so to have us break through with a #1 song was groundbreaking."

The band, from California's Inland Empire, was one of the first acts signed to Eazy-E's Ruthless Records back in 1987. They created one of the original cracks in the glass ceiling for women in rap. And, while artists like Salt-N-Pepa and later, Lil' Kim, Missy Elliott, and Nicki Minaj managed to make more cracks in that ceiling, there is still a long way to go before shattering.

"I think women in rap have come a long way, but I still feel like there aren't enough females out there. You have maybe two to three popular females in rap now and that's sad. What's even worse is that there are NO female rap groups anymore, NONE!!!!"

While J.J. Fad continue to tour and perform, their main focus has turned to their lives outside the music world.

"Making music is definitely something that we love, but now we are having so much fun on the road and performing on stage that we are focused on that and it doesn't leave much time for us to record in the studio. We all have kids and our kids are super busy with sports, educational responsibilities, etc. We are super involved in our children's lives so that takes a lot of our time as well. We do plan on making new music in the near future but, as for now, we are just taking it one day at a time."

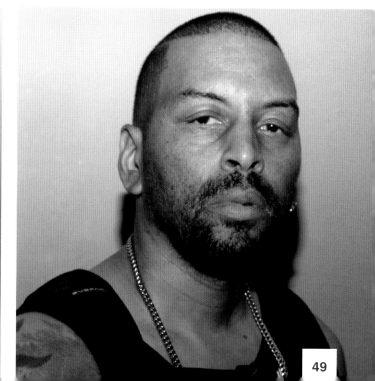

Cindy Wilson

The B-52s are legendary. They burst out of the Athens, Georgia, scene with party songs like "Rock Lobster," "Planet Claire," and "Private Idaho," building their fan base throughout the 80s. After founding member Ricky Wilson passed away from AIDS in 1985, the band's future looked uncertain. Drummer Keith Strickland switched from drums to lead guitar and they recorded 1986's *Bouncing Off the Satellites*. But it was 1989's *Cosmic Thing*, with its massive singles "Love Shack" and "Roam," that brought the band huge mainstream success.

Amidst this success, Cindy Wilson was still devastated by the loss of her brother. "The B-52s are like a family," she tells me. "But I guess I hadn't finished grieving for Ricky and I wanted to go back and hang out with my family. I just felt the calling to go back to Georgia." She and her husband intended to move back to New York City and kept saying they would do so in another few years, but time moved on. They started a family and life in the Athens/Atlanta orbit just worked for them.

Though Wilson was in and out of the B-52s throughout the 90s, she is now firmly rooted in the band and touring with them

regularly. In 2017 the band marked its fortieth anniversary and they did a bunch of touring to celebrate.

In 2016, Wilson also started recording solo material in collaboration with musicians Suny Lyons, Ryan Monahan, Lemuel Hayes, and Marie Davon. While she had done some informal recording before, these songs were what she called "the real deal." A mix of electronica and psychedelia, the songs are performed in a swirling, hypnotizing stage show that has her twirling amongst dreamy and surreal video images, each song melting into the other.

With the solo work, she wasn't given a free ride. "I wasn't the B-52s brand. I've had to prove myself the whole way. No one's given me any breaks, but we've gotten this far! People are curious though. 'Cindy Wilson from the B-52s? What's she doing?'"

She is excited to do more solo work in the future and is trying to write at least a song a month—even with the B-52s' hectic touring schedule, which she loves doing.

"I must enjoy touring, I keep doing it! It's always an adventure."

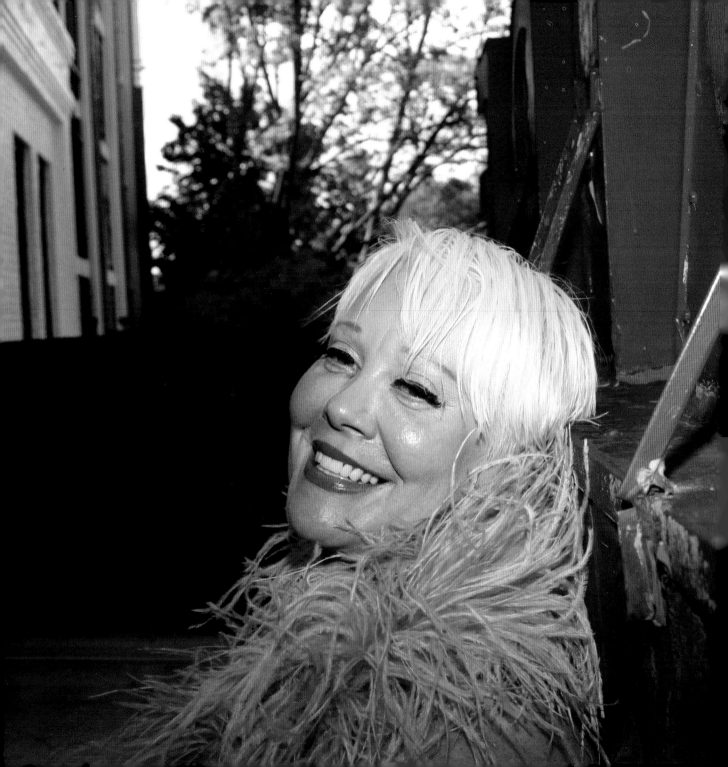

Chris Difford

At first glance, I might be walking in a western London neighborhood with a friend from work—just two men beginning the commute home. But, instead, I'm walking down the street with Chris Difford of the seminal British pop band, Squeeze! Difford cofounded the band after he posted a sign in a sweet shop window looking for bandmates. Glenn Tillbrook responded and the rest is history. What came after was "Tempted," "Cool for Cats," "Up the Junction," and too many other classics to mention.

Today, Difford is still active with Squeeze, making new music and touring the globe. He also creates solo work "as a hobby." In addition, for the past twenty-five years, he has hosted two retreats per year in which he mentors emerging and established songwriters.

For Difford, making music now "is as passionate as back in the day, more so. Getting older reminds me of swimming, you reach the end of the pool, you turn round and you go back to where you came from. As you get older, you just swim slower."

At the end of our walk, I'm still a bit confused about the office to which he is commuting—it doesn't seem very "rock and roll." Difford tells me, "My office in London is for me to find the balance in my solo world and within the walls of Squeeze world. I have a manager who carefully guides me through the balancing act, it's not easy sometimes but mostly it's all about the lunch."

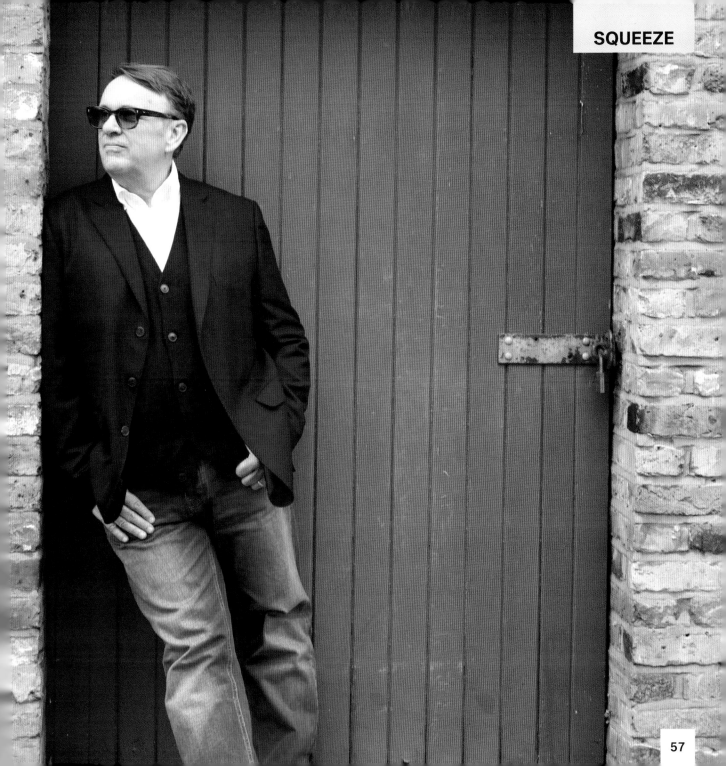

David Newton

David Newton was a driving force behind The Mighty Lemon Drops, one of the most criminally overlooked bands of the decade. With songs like "Inside Out" and "Out of Hand," they were often compared to Echo and the Bunnymen.

"Don't get me wrong, we loved the Bunnymen, but we were all influenced by the same things from the 60s—The 13th Floor Elevators, The Velvet Underground, The Byrds. We were fine with being compared to them, but it did kind of get old."

By 1989–1990, with bands like The Stone Roses and The Charlatans entering the music scene, The Mighty Lemon Drops were already considered an "old band" by U.K. standards. They disbanded in 1993 and Newton began working at a London record store known for hiring musicians—some of his coworkers were members of Jesus Jones. He played with other bands for a while and, in 1995, decided to set out for Los Angeles to start a new life with his wife. He converted their garage into a recording studio, mostly for his own needs. But, after recording a friend's band there, word got around and it soon became a somewhat thriving business. He's recorded The Little Ones, The Soft Pack, and The Blood Arm there in recent years. He doesn't want to say it's his "career" now, but he admits that engineering and producing records pays the bills.

Although he prefers to work with bands rather than lead them, he has gained the confidence to be a front man. He released a well-received EP in 2012 called *Paint the Town* and has plans to follow that up with another.

There have definitely been offers to get The Mighty Lemon Drops back together. However, logistics have made it difficult as most of the band members are scattered around the globe and busy raising families.

I ask him about the increased interest in all things 80s. "It's part nostalgia, it's part younger kids re-discovering this kind of music," he says. "There are a lot of bands these days that are taking that jangly guitar influence which a lot of our bands had—and we were influenced by late 60s psychedelia and The Byrds and The Doors and stuff like that. It all kind of goes in cycles."

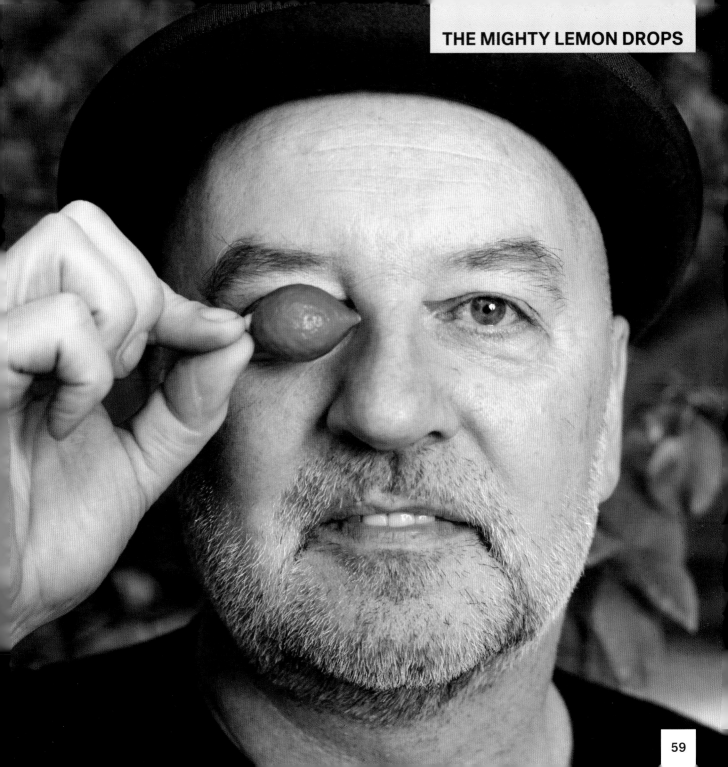

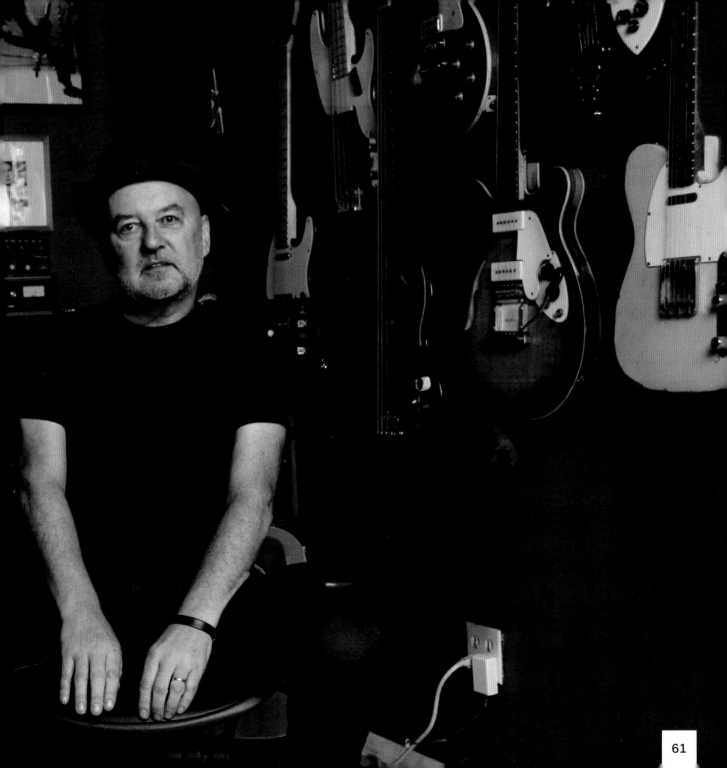

Johnette Napolitano

"Turn left when you see a sign for the lake. Then turn right on this road, left again where it forks and then keep on until you see a white post in tires with a red top."

A lake? Out here in the desert? A white post?

I was thinking I was lost. As the wheels of my rental car were slipping softly in the desert dirt, I began thinking how everyone always warns you to never go to the desert without adequate supplies. After a couple of false starts and odd directions, I finally find Johnette's little slice of desert paradise. I tell her my difficulties in finding the place and she responds, "Oh, you listened to your phone didn't you? Never trust your phone in the desert."

Many people might associate Concrete Blonde with the 1990s and their big hit "Joey," but I wanted to include them in this book because the late 80s was when their music came into my consciousness. "True," "Cold Part of Town," and "Still in Hollywood," from the band's 1987 self-titled debut, all had a big impact on me. I remember desperately wanting to see them at the Lost Horizon in Syracuse, New York, but was forbidden from doing so when my mother found out it was a bar.

Concrete Blonde formed in the mid-80s in Los Angeles, born out of the post-punk scene that produced such iconic bands as X and The Go-Go's. They were a committed band, playing lots of gigs and constantly creating new music, but they didn't quite fit into the trendy new-wave styles popular at the time. Record companies tossed them some silly demo deals, but it wasn't until Miles Copeland at I.R.S. Records signed them that they really took off.

Today, Johnette lives out in the Mojave Desert, far from Hollywood. I've often found this place magical—the hot sun baking the desert ground all day and, at dusk, seeming to glow out from the earth itself. "It's the quartz," Johnette tells me. "All of Joshua Tree sits on a gigantic quartz bed."

Johnette ended up out here after selling her Hollywood home. While she began building a new home near the ocean, she needed a place to stay that wouldn't eat up a ton of money and kept looking farther and farther out into the desert. She says, "I lived in Baja, Mexico, for awhile and loved it, and the desert made me feel like I do in Mexico. I finally said, screw it, I love it out here, and bought a house out here. But as anyone who lives out here will tell you, no one winds up out

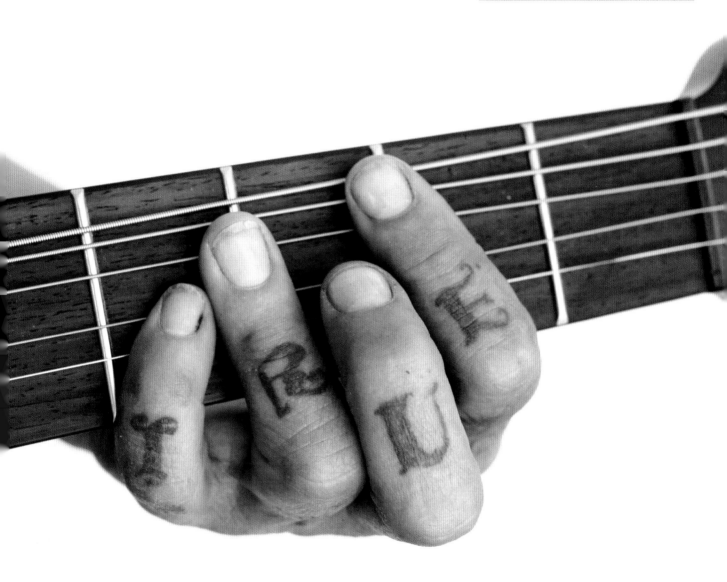

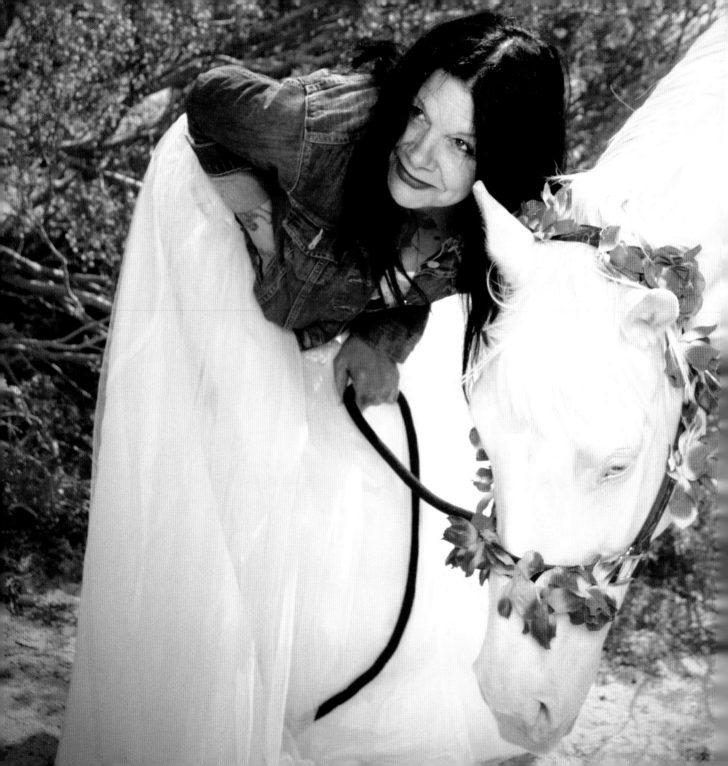

here by accident. For that matter, no one winds up anywhere by accident."

Here in Joshua Tree, Johnette began housing rescue horses. She doesn't foster the horses anymore, but she's given a beautiful white horse named True a forever home. As Johnette and I talk, True hangs out in the yard, her sensitive eyes covered with a special mask to protect them from the sun. Johnette's love for this horse is apparent as is her undying artistic drive. As she walks me around her home telling me of the many projects she's working on—writing new music, creating dresses from unique reclaimed fabrics, building a space to create films and art, expanding her tattoo work—it is clear that Johnette is still doing things on her own terms.

"I am acutely aware that the future, at this point, is a very finite amount of time in which I must contribute all I can to comfort, nourish, and inspire the human spirit now and forever, 'cause music is the only thing that'll outlive everything else."

As for her legacy? "History judges us all, doesn't it? I don't think that's for me to determine. But I know one thing: 100 years from now someone hears a song, they can bet that was me, truly and purely, and I fought hard for exactly that . . . that is what art is all about."

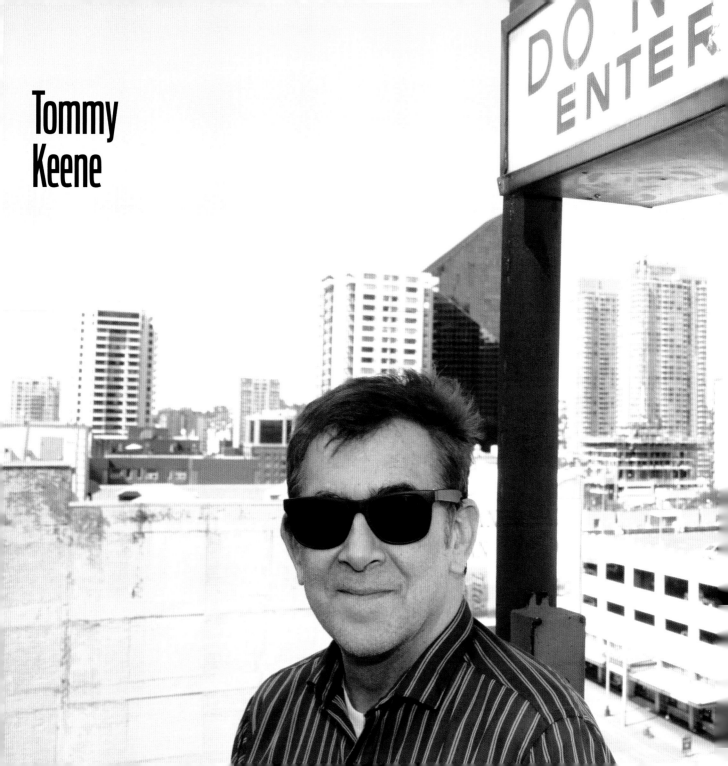

From the time Tommy Keene saw The Beatles perform live on *The Ed Sullivan Show*, he knew exactly what he wanted to do.

"Oh yeah, I remember seeing that. It was the most exciting thing ever. It was as if they were from Mars or something. It was just so amazing. I kind of never looked back. I knew exactly what I wanted to do."

He went on to record and release *Songs from the Film* in 1986, establishing a following of admirers and musicians. He continued to record a stellar collection of hooky, jangly-guitar songs throughout the 80s and 90s and, along the way, ended up touring and working with everyone from Paul Westerberg and Ivan Julian to Robert Pollard and Matthew Sweet. He loves touring with them as much as he loves touring solo.

"When you're not the lead singer or the leader of the band, it's just completely different than being in the spotlight. Once you've been in the spotlight, moving to the other side of the stage, you just realize how much weight is off your shoulders. I love it. I just love to play guitar."

He continues, "I'm making records for myself and anyone who's interested these days. Back in the 80s, when I was putting out records and was on a major label, it was a completely different ballgame because there were so many cooks in the kitchen—they want you to do this, they want you to do that, put this picture on the album cover. A lot of times, if you didn't sell a lot of records, you didn't have a lot of say. That's all changed now. The whole industry has changed. Now it's pretty much the wild, wild west. You do whatever you want as long as you sell a certain amount of records. And, as long as people are still willing to put out my records, I'll keep doing it. I'm not trying to write a hit for the radio. I'm not trying to write a song that will translate into a video. I'm obviously doing it because I love it, and when it stops being fun then I'll stop doing it. I've got a small crowd and I've been fortunate enough to work with people whose music I love and that's sort of all that I can ask for."

Note: The sad news of Tommy's passing arrived as this edition went to print.

Midge Ure

Midge Ure has been all over the musical map: starting out in a "boy band" called Slik, moving on to work with members of the Sex Pistols and Visage, taking over as the lead singer for Ultravox, and finally, working as a solo artist. He even did a brief stint touring with Thin Lizzy!

But, he is perhaps best known as the cowriter of the charity song "Do They Know It's Christmas," along with Boomtown Rats' Bob Geldof. The song is a legacy that still looms large in his life.

"Once you get involved in something like Band Aid, you can't walk away from it. Even if we never fundraise again, the song will keep generating income for the Band Aid Trust in perpetuity. The world changed just a little after that was written."

For me, I still remember sitting in the dark watching *120 Minutes* on MTV and seeing the black and white video for Ultravox's "Vienna" flicker before me and thinking, "What is this?" It's moody electronic vibe still resonates and sounds fresh today.

In addition to his philanthropy work with the Band Aid Foundation and Save the Children, Ure still regularly tours the globe playing his solo hits as well as classic songs from the Ultravox canon.

Vanessa Briscoe Hay

She won't admit it, but Vanessa Briscoe Hay is like an ambassador of Athens, Georgia's varied music scene—memory holder and archivist of the stories of her band and the people she played with.

"I've been all over the country and I haven't found a place that ticks all the boxes like Athens does. It's not too big, it's not too small, it's got a cultural scene, it's closer to an even larger cultural scene, it's got a wonderful extended community, I like the terrain, I like the green rolling hills. After you've been here so long, you know everyone and everyone knows you. People accept each other here. It's a very accepting and diverse community."

Her band Pylon rose from the early 80s music scene in Athens alongside R.E.M., The B-52s, Love Tractor, and The Method Actors. They released a couple of albums that proved influential to later acts like Sleater-Kinney, but at the time were not huge hits.

"I'm still surprised people even remember us," Hay says with a laugh. "This whole thing started when Randy [Bewley, guitarist of Pylon] came in to where I was working and

asked me to audition. I went in and they told me what it was about. The premise was that Pylon would go to New York, get written about in *New York Rocker*, and then break up. And I said to myself at the time, this isn't going to take up much of my life. I had no idea this was going to be anything other than a few months." This was in 1979, and they didn't get written up in *New York Rocker*, they got written up in *Interview* instead!

After some breakups and makeups, Hay went to nursing school and started a family, raising two daughters in Athens. As her children were getting older, Hay and the rest of Pylon started looking over their old masters, thinking they might re-release their earlier work. They discovered that James Murphy (of LCD Soundsystem) and his label DFA were thinking the same thing and, in 2009, they reissued the first two Pylon records, *Gyrate* and *Chomp*.

That same year, Randy Bewley suffered a heart attack and passed away. "As far as we were concerned, that was the end of Pylon. You couldn't substitute anyone in the band and be Pylon anymore."

Today, Vanessa is happy re-discovering her painting, working in her garden, performing occasionally with her band Supercluster and performing Pylon songs with the Pylon Reenactment Society. She also continues to be a huge advocate for Athens and its musical history.

Ivan Doroschuk

Men Without Hats' two big hits, "Safety Dance" and "Pop Goes the World," are still undeniable in our pop culture. You're likely to hear one of the songs in a commercial, on television, at a karaoke bar, in the movies, or even on the (gasp!) radio. Singer, and head man-without-a-hat, Ivan Doroschuk is proud of this fact. After a ten-year hiatus staying at home raising his son, he is content to now go out on the road and play the hits for the fans, who are thrilled to dance along . . . if they want to. His now grown son even accompanies him on tour.

In person, Doroschuk is soft-spoken and you can sense his happiness as he looks around at the mountains and water surrounding his Canadian home. However, he's not as happy with the way the music business has evolved over the years. "The Internet has sucked every last bit of mystery out of rock and roll," he says. "The fans now have a hotline to the stars that serves to break down the barrier between them and the artist, and removes the sense of 'specialness' that used to drive the industry. Fame is the name of the game now, and if you can't make it in music, you can always become famous just for being obese, or a meter maid, or a dwarf, or the worst driver in Canada."

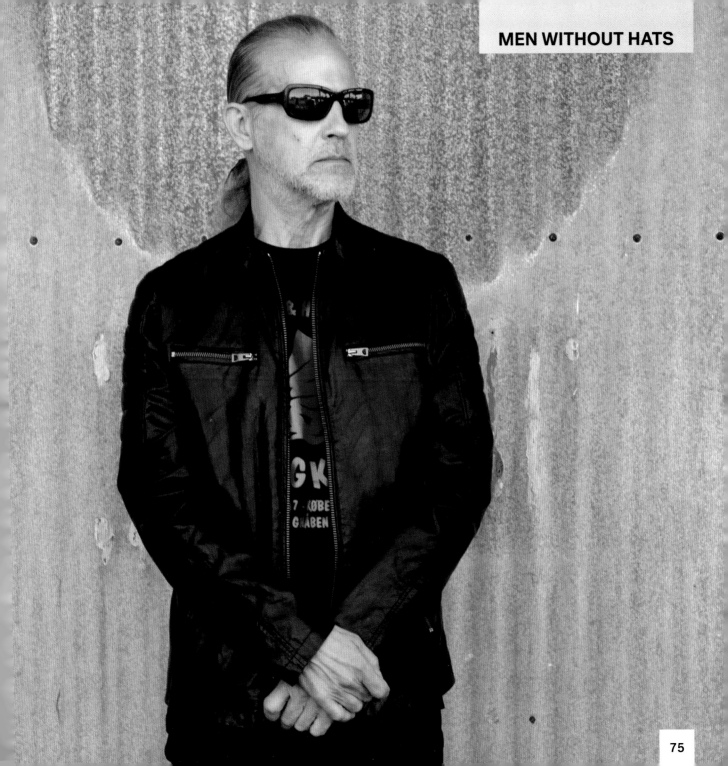

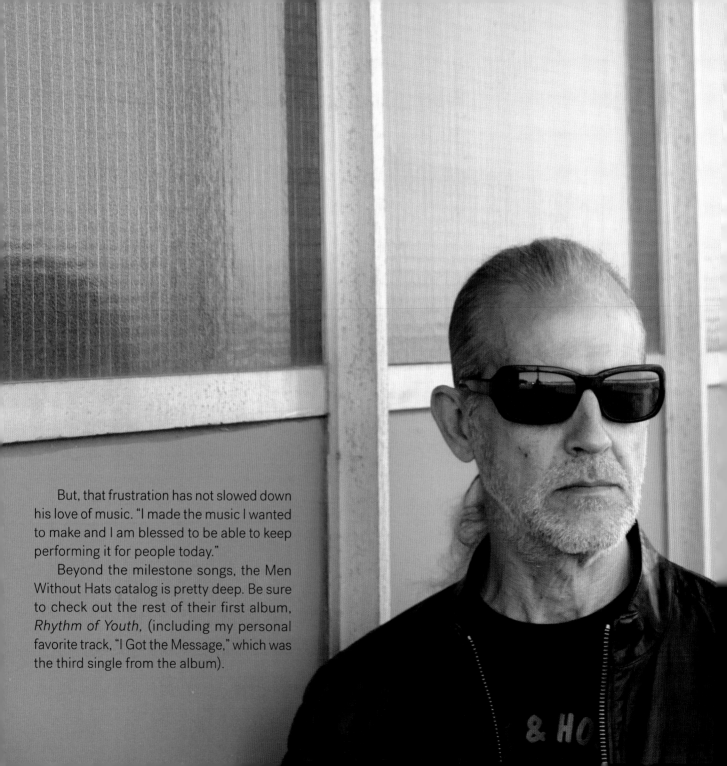

But, that frustration has not slowed down his love of music. "I made the music I wanted to make and I am blessed to be able to keep performing it for people today."

Beyond the milestone songs, the Men Without Hats catalog is pretty deep. Be sure to check out the rest of their first album, *Rhythm of Youth*, (including my personal favorite track, "I Got the Message," which was the third single from the album).

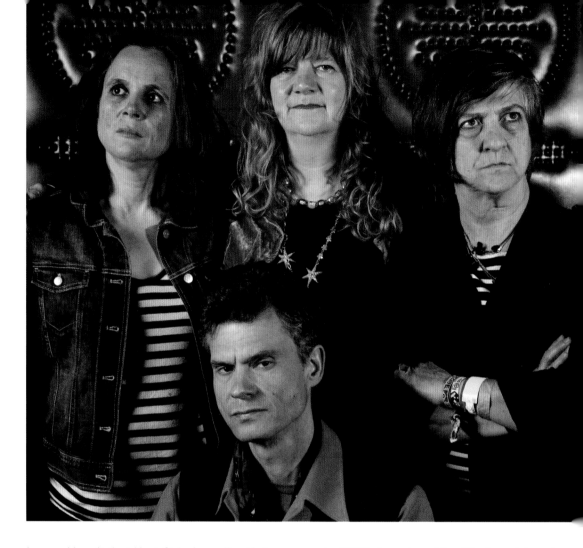

The Raincoats

Legend has it that Kurt Cobain walked into a record store in London to buy a copy of one of The Raincoats' albums and was told that founding member Ana da Silva was working in a shop around the corner. Cobain had been a huge fan of the post-punk pioneers and convinced Geffen to re-release some of the band's early 80s records, bringing their influential sound to a new generation of listeners. An album of new material was released in 1996.

In 2009, founders Gina Birch and Ana da Silva created their own label, We ThRee, to release their music. Most recently, the band's music featured prominently in the film *20th Century Women*, where Annette Bening's character hears the music and says, "Why can't things be pretty?"

The band still retains its youthful energy and brings that to the stage when they tour, as well as that unique perspective and voice.

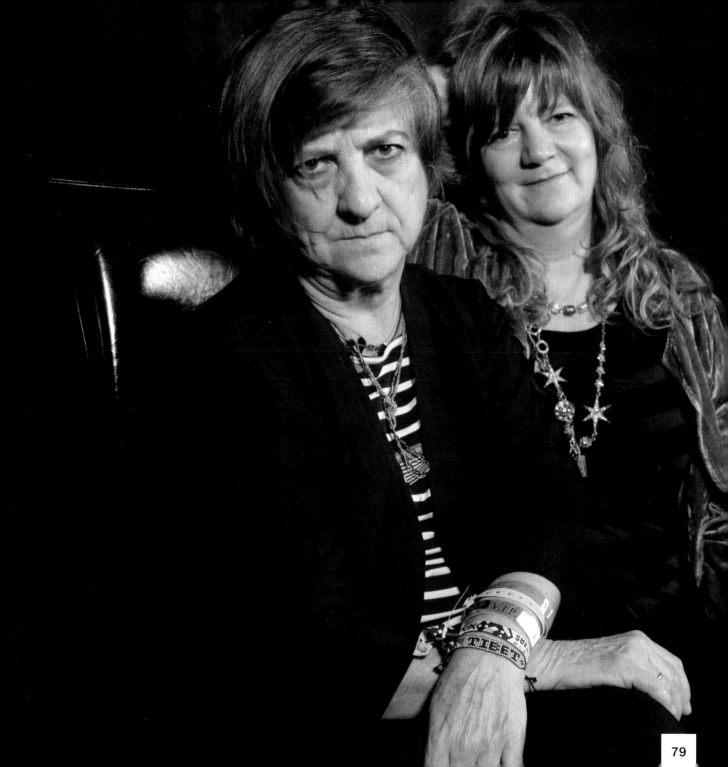

Marv & Rindy Ross

Quarterflash's debut album sold more than a million copies, fueled by the success of songs like "Harden My Heart" and "Find Another Fool." On first glance, it seemed as though the record company was pushing vocalist Rindy Ross to be the next Pat Benatar, if Benatar could also kick ass on one of the quintessential 80s instruments—no, not the synthesizer, the saxophone!

"For the most part we were able to express ourselves musically as we chose—without much record company interference—while we were under contract," Rindy says. "We weren't teenagers when we got signed, so we knew what we wanted and, maybe more importantly, what we didn't want."

Today, Marv and Rindy Ross, high school sweethearts who formed Quarterflash back in 1980, are still together and still active with music. Marv's musical *The Ghosts of Celilo* was the result of a ten-year collaboration with Native American musicians and actors and debuted in 2011. They also continue to record and perform shows with Quarterflash, The Trail Band, and as a duo.

I ask about what they felt they could have done differently in their career. Rindy tells me, "I wish I could have been more present and less self-critical during the early touring years and big arena shows. I could have allowed myself to have more fun. As we have gotten older, and maybe wiser, we have both tried harder to be in the now and feel grateful for the current moment."

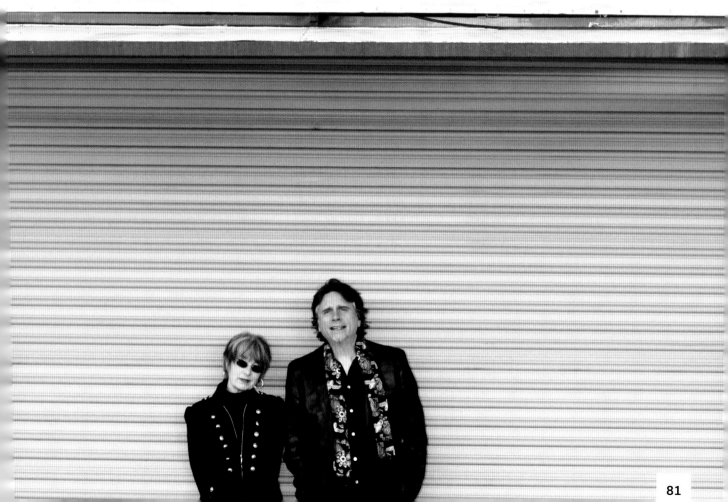

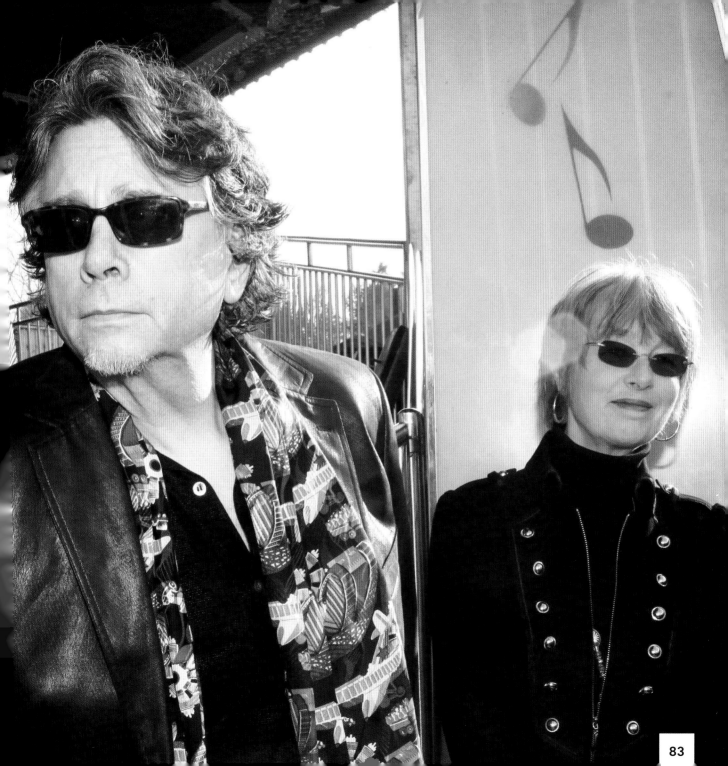

Vic Varney

If you don't know The Method Actors, think a little bit Talking Heads, a little bit Wall of Voodoo, and a sprinkle of Athens, Georgia's magical musical dust, and that should give you a better idea. As singer-songwriter Vic Varney tells me, they made music that "the writers liked." And indeed they did, as much praise was heaped upon them by the musical press.

By 1983, the band had parted ways. Varney, tired of the endless touring, went back to school and got a master's in art history. After he finished school, he began teaching English and found that he loved it. He relocated to New York City, teaching at Columbia and the New School and, later, full time at New York University. He still played and wrote new songs—the man has tons of material he's never released.

"I've got a massive stash of totally unlistened-to material I'm hoping will come out. I've spent every penny I've earned—I've turned it back into music. I have enough money that I don't depend on it returning any money. I've done nothing to promote it. The writing, the recording of the music interests me—nothing else does."

Marriage brought him back to Athens, where he lives now (though recently divorced). Music is his life nowadays. He is constantly playing and writing new material and regularly travels up to Nashville to record new music with friends.

"I have never been more into music than I am right now. I'm just totally, totally immersed. I've had a really interesting but, in many ways, pretty deflating life But, of all the things you could find to ease the passage of time, I've found a great one. Not just music but songwriting and, recognized or not, I don't feel bad about having made that choice. I'm really immersed in music. It's OK if you didn't get the Ferrari, if you didn't get the cover of *Rolling Stone*, if you didn't get the girl, you at least had something great to fucking take up your time."

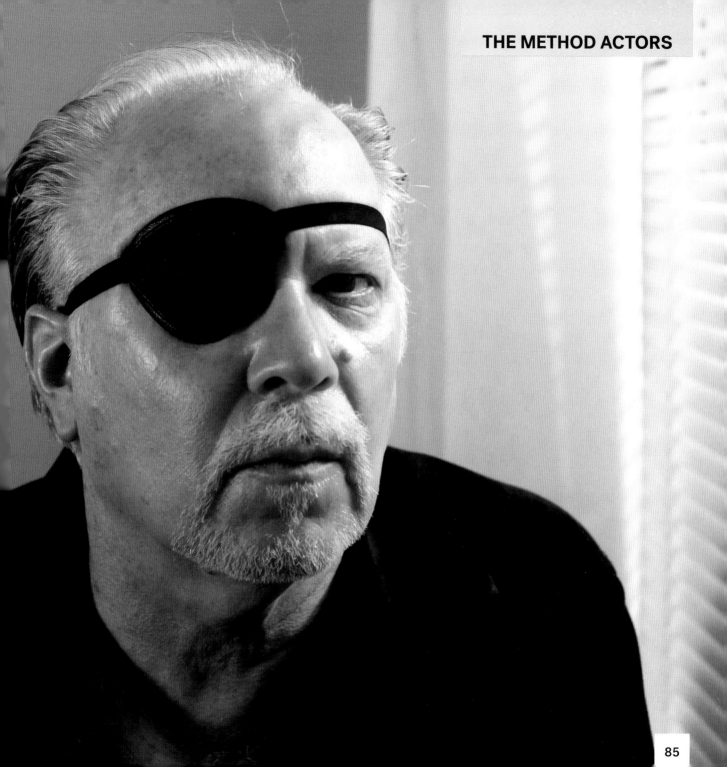

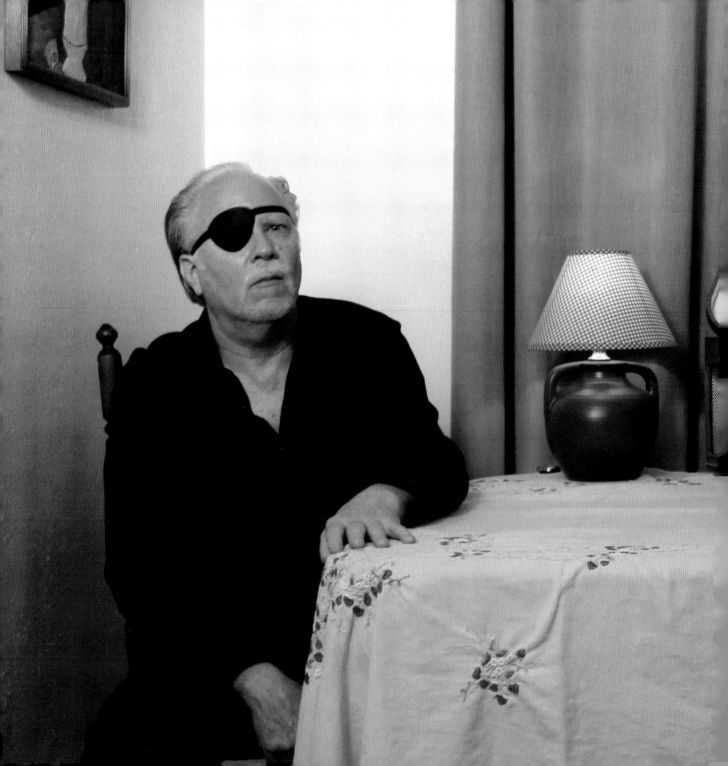

Carol Decker

T'Pau's "Heart and Soul" was on the radio all the time when I was a teenager working at a wallpaper store in upstate New York. It may have even been on the radio when a fire extinguisher I had been fiddling with accidentally went off and started squirting foam all over said wallpaper store! I think that Carol Decker, the voice behind that song and "China in Your Hand," would have appreciated that with a hearty laugh. She has such a positive energy, it's hard to be in a bad mood when you're around her. Even though we had just met, she acted as though we were old friends and it was easy to slip into that role.

We were talking about her next gig, a slot in one of those 80s reunion tours. "It really is great fun to be part of people's memories, the soundtrack to their youth. These gigs have such a great party atmosphere." The flip side, of course, is that audiences tend to want their musical memories to be consigned to the past, not wanting to hear their new music. Even with the Internet, it's hard to get new material out there in the world.

She doesn't dwell on this too much—she's still writing new music (with original T'Pau member Ronnie Rogers), performing, and raising two children with her husband.

"I have a fuller life now, with kids and a home to run, so I don't dedicate myself to music as I used to. My life was just about being in the band before. It was all I did."

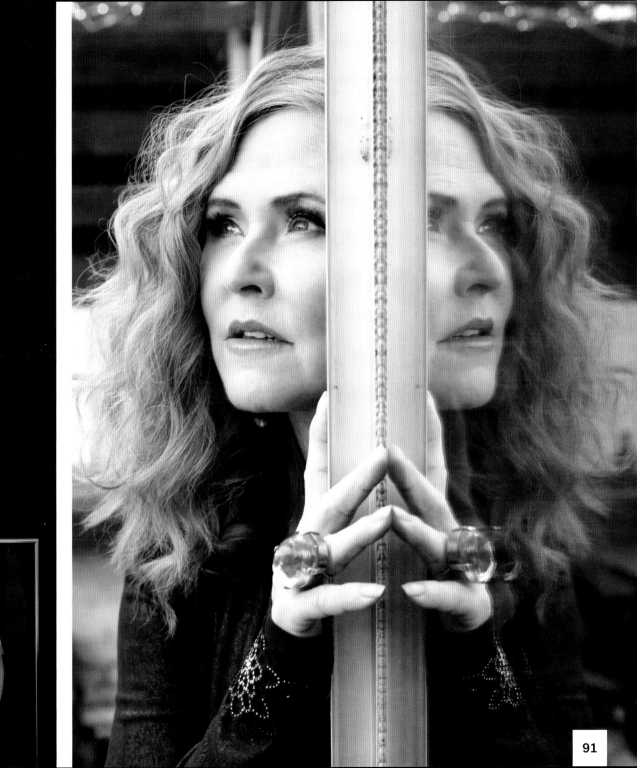

91

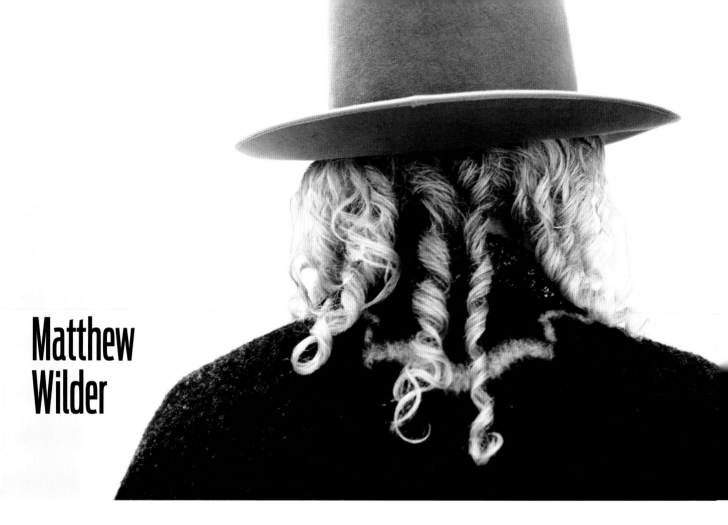

Matthew Wilder

The optimistic and upbeat song "Break My Stride" is how most of us know Matthew Wilder. But both before and after that mountain-sized highlight in his career, Wilder has led a full life in the music business. When he was nineteen, he was discovered by an agent and producer while busking in Washington Square Park. Not long after that, he was flown to Los Angeles to make a record. "Break My Stride" was released and became the massive hit we know today.

Fast forward a bit and a story of record company politics and turmoil emerges that prevented Wilder's follow-up album from ever reaching the same heights as "Break My Stride." At that point, he opted to return to his songwriting roots and began writing songs for other people at Geffen. He eventually moved over to Interscope, where someone saw his work and asked if he would be interested in producing. What followed was

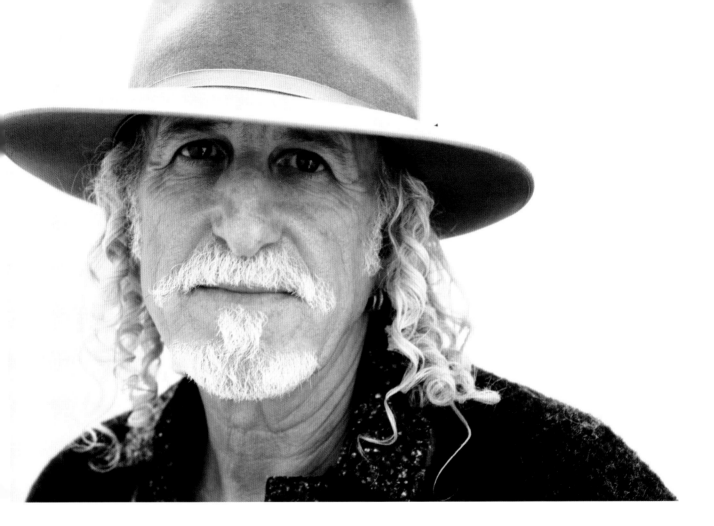

Wilder's production work on one of the 90s biggest albums, No Doubt's *Tragic Kingdom*.

One of Wilder's real passions has been the thirty-year long effort to bring a musical version of Anne Rice's *Cry to Heaven* to the stage. "People were knocked back on their heels that I could write this kind of music because I was known for a very particular style. They weren't used to it, it's very orchestral, operatic at times. I was classically trained and I was really digging back into those roots to be able to inform the language of the music that I had written. You don't really get to use a lot of that in the pop world. You're lucky if you get three chords!"

In person, the passion for this project (and music in general) is palpable. Music is one of the things that just radiates around him. As he sits at his piano playing for me, he says, "I create because that's what I believe I was put on this planet to do."

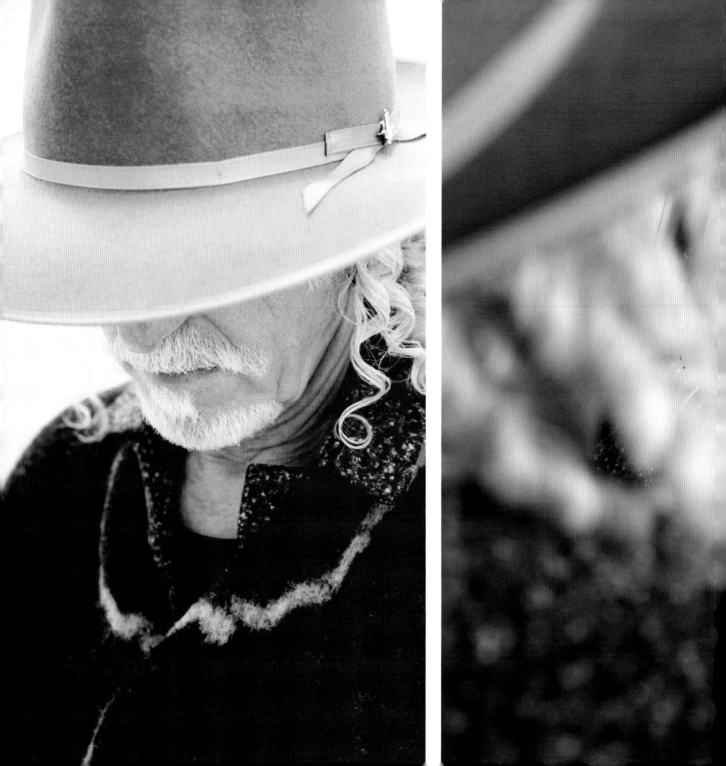

Johnny Hates Jazz

By the time "Shattered Dreams" started climbing the charts in the United States, Johnny Hates Jazz had essentially broken up. After the song blew up in Europe, their record company began pressing them for a complete album. An intense touring schedule to promote the new hit ensued and all of this pressure culminated in Clark Datchler leaving the band in 1988.

The members of the band never really left the world of music. Clark went on to record solo material while Mike Nocito launched a successful career behind the scenes as an engineer and producer. Around 2010, Clark was writing material that he felt had a Johnny Hates Jazz vibe and reached out to Mike about rekindling their collaboration.

"When I left the band in 1988, there was always a feeling of unfinished business . . . that, one day, we would come back together and complete our journey as a band together. I had written a song for my *Tomorrow* album called 'Nothing Left To Lose.' It was the first time I had delved into the JHJ part of me for many years, and I really liked how it turned out. So I wrote another song in a similar vein,

called 'Magnetized.' I started to feel that it would be best as a JHJ track, and so I called up Mike. We met for lunch in Cambridge (where he lives), and it was that classic experience of not having seen someone for so many years, yet feeling like you had spoken no longer than a week ago!"

The meeting eventually turned into new recordings, which were released in 2013 on the album *Magnetized*. Unfortunately, Clark collapsed in London while working on a second single and was diagnosed with a rare form of cancer. Due to his long hard road of recovery, the album lost a bit of its steam. Nevertheless, the band tapped into their fan base and went on the road with a series of live shows. They plan to continue touring and hope to create new music together in the future.

"Do I feel I am making the music I want to make right now? No, but it is rare that I ever have," Clark tells me. "That is the unending quest of the creative. We all feel our best work is yet to come—whether that is true or not!"

John Easdale

John Easdale has music running through his veins. He's practically spent his life in record stores. He worked in and even owned a record store, the early incarnations of Dramarama performed in the basement of a record store, and he naturally drifts towards a record store as we're walking and talking. He browses through the stacks, pausing to lift one out for closer examination every now and then, and even settles on a purchase. It's obvious he's a regular here and, as we leave, he asks the guy behind the counter to say hello to the owner.

"The record business, by and large, no longer manufactures little plastic circles with holes in the middle. As a result, there are fewer stores in which to buy them and fewer machines on which to play them. I think popular music was a much more important part of the average person's life back in the days before VCRs, cable TV, video gaming, and the Internet. Some of my most treasured memories revolve around those little plastic discs. The first *big* decision I remember making was whether to buy The Beatles or The Monkees. I can't imagine childhood/teenage

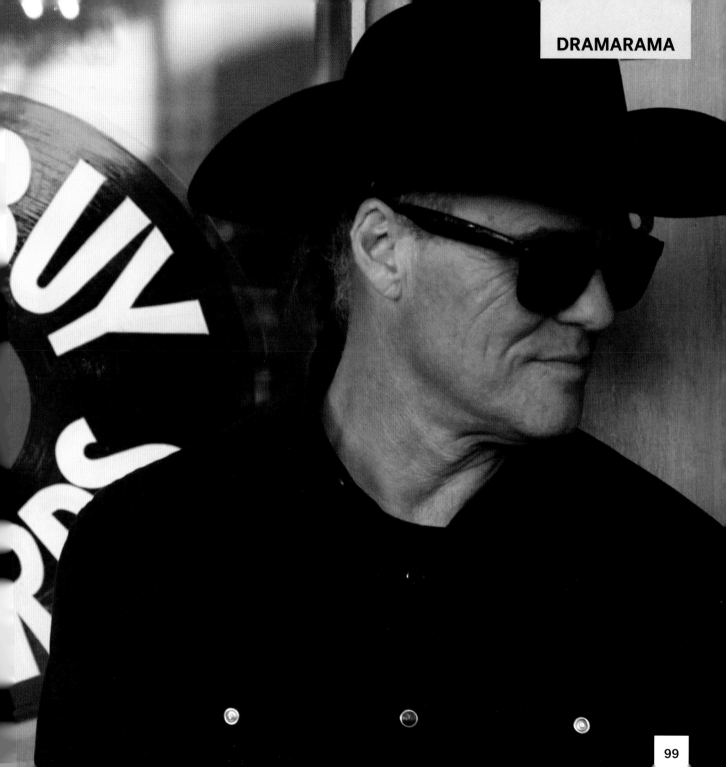

years without the thrill of actively discovering and acquiring new music. The art of curating a collection has been crushed, completely subjugated by the multitude of music available, with or without artist consent or compensation, at your fingertips. It's the magic that is missing; the music to industry ratio is way out of whack."

"Anything, Anything" was a huge hit for Dramarama back in 1985. Other songs followed (notably the just-as-good "Last Cigarette") but none reached the ubiquity achieved by "Anything, Anything."

"I have always been amazed by the amount of attention that song has received, and continues to receive, compared to all the other songs we have written and recorded," Easdale says. "It is an extremely personal song describing actual events in my life long ago, but for some reason it resonates with a larger percentage of the population. Any resentments I may foster for primarily being known for that one song are silenced when I hear 'Anything, Anything' on the radio thirty plus years later, and absolutely buried by the reaction of the crowd when Peter [Wood] plays those first few notes and the song becomes an audience sing along. Ironically, the recognition received by a song about the painful and tumultuous break-up of my first marriage allowed me to move to California where I am now living happily ever after."

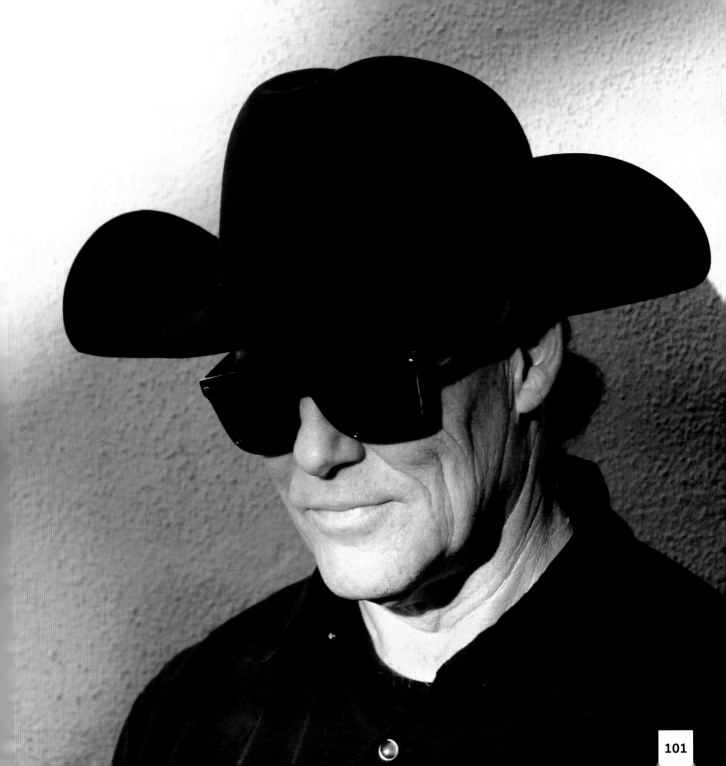

Modern English

What is the quintessential 80s song? I think many of us could make an argument that "I Melt with You" would definitely be considered a serious contender for that title. For a song that's enjoyed such longevity, it's a bit of a surprise to hear singer Robbie Grey say that the lyrics to the song, about young lovers dying in a nuclear blast, were written in only two minutes. And now it's burned into our collective Generation X consciousness, a common touchstone we all share regardless of whether you were a brain, an athlete, a basket case, a princess, or a criminal.

The band broke up and reformed in various incarnations over the years, with Grey creating music with other bands, going back to school, and opening a vintage clothing shop in the off times. The original lineup of Grey, Mick Conroy, Gary McDowell, and Stephen Walker reformed in 2010 and recorded a new record (*Take Me to the Trees*) in their Suffolk recording studio and continue touring all over Europe and the U.S.

When I ask about some of the breakups, they laugh a little and brush it off, not wanting to dredge up things long gone by and resolved. Today, the band seems relaxed, joking easily amongst each other. They seem a bit like family, their love and admiration for one another evident.

On whole, the band is more relaxed about things nowadays. Without the pressure from record companies, they feel free to make the music they want to make. Plus, it doesn't hurt that "I Melt with You" has paid the bills for quite a long time and they're able to just follow their creative impulses.

"The 80s definitely had a major influence," Grey tells me. "I think younger people see it as a productive and creative time, like maybe we would have done with the 60s and 70s."

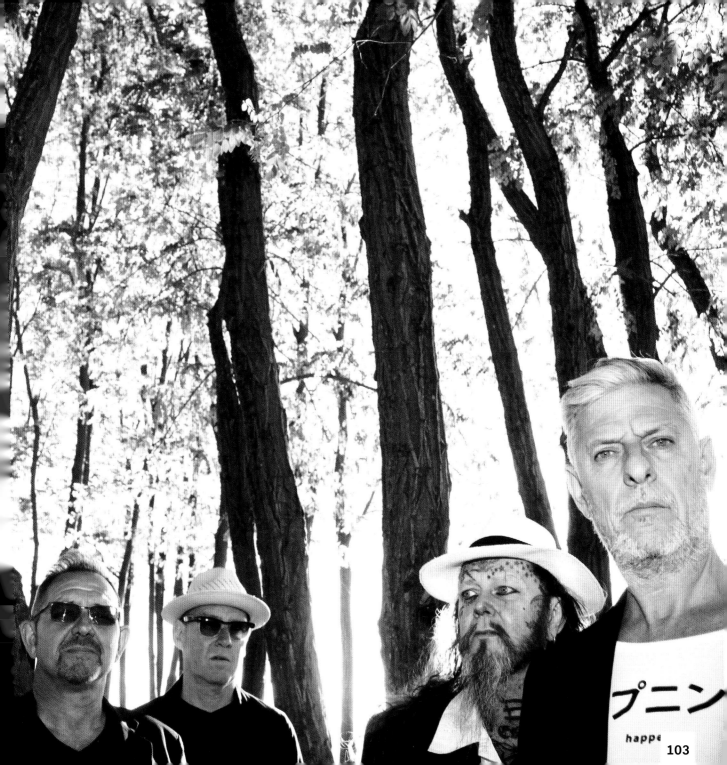

Cindy Lee Berryhill

Cindy Lee Berryhill and I agreed to meet at The Triple Door in Seattle, the venue where she would be playing that evening. We had each been there several times before, which meant we both knew there was a fantastic curtain of lights we wanted to use in our shoot. As we were waiting for the lighting guy to arrive and power up the lights, we bonded over our shared love of XTC.

"I'm a huge fan of XTC's *Skylarking*, Brian Wilson and The Beach Boys, The Velvet Underground, Beatles, early Stereolab, Nick Drake. I could go on. I don't hear their music in my head when I'm writing a song or arranging . . . the influence of others happens earlier in the intention . . . like wanting to make an album that holds together like a piece of art, which *Skylarking* is."

One of the leading lights of the "anti-folk" movement, Berryhill headed to New York City from California in the mid-80s to carve out a spot in the musical landscape. She released several critically adored albums, including her debut *Who's Gonna Save the World*. But her musical career was put on hold in the mid-90s when her husband, *Crawdaddy* Magazine founder and writer Paul Williams, developed a brain injury as a result of a bike accident. He eventually developed dementia and Berryhill took a break from music to care for him and their young son until Paul passed away in 2013.

Today, she's back to recording music and touring, having released *The Adventurist* in 2016.

"I've always made the music I wanted to make. I was never a major label artist with a bunch of money riding on me. I started out with two records on indie label Rhino Records. Then six years later, in the midst of the grunge thing, I really discovered my sound. I put two records out on the little San Diego label Cargo Records. The first Cargo record, *Garage Orchestra*, is where I discovered my love of and ability to arrange for multiple instruments. My new album, *The Adventurist*, picks up where that left off. An adventure in low key orchestration alongside rock instruments. Fun!"

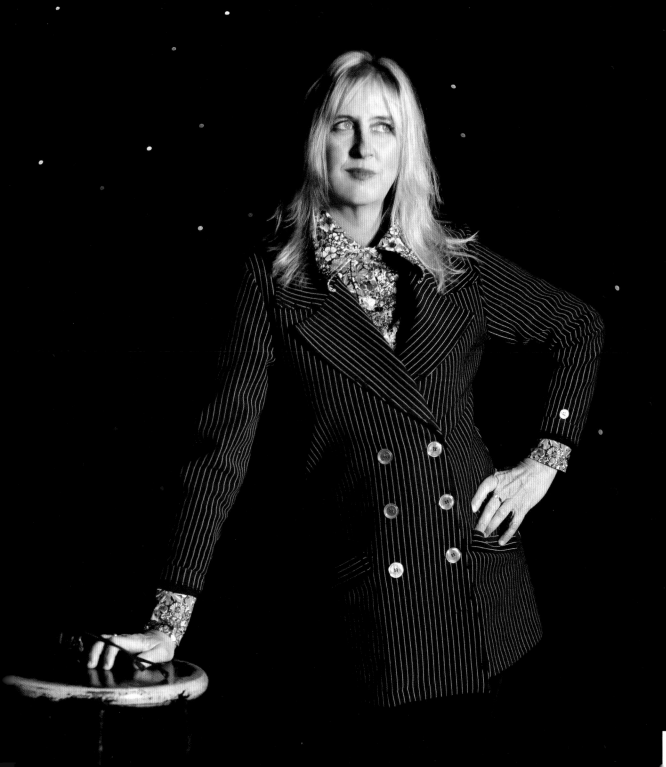

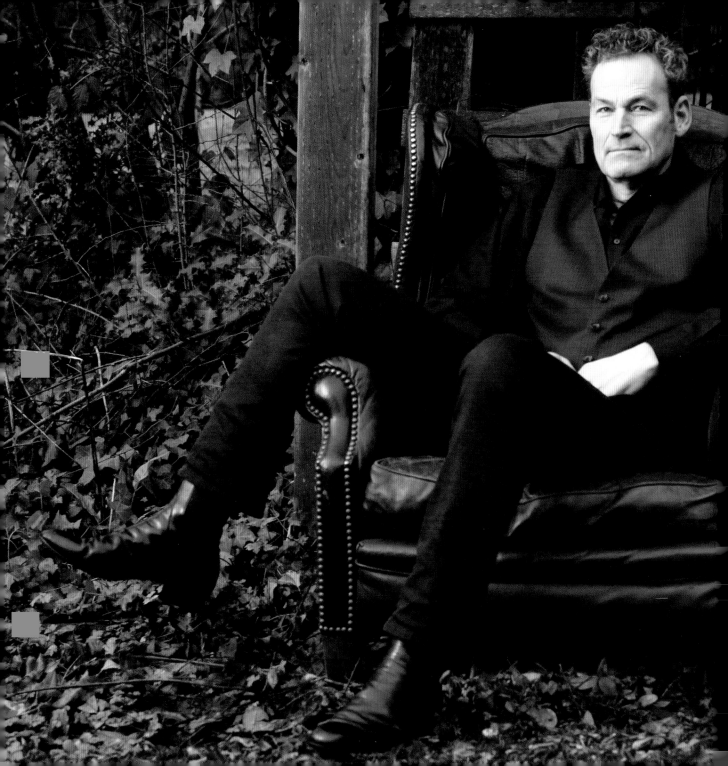

Bill Wadhams

"Obsession" was *the* song of 1985—right up there with Madonna's "Like a Virgin," Simple Minds' "Don't You (Forget About Me)," and Howard Jones' "Things Can Only Get Better."

The success of that song was hard to repeat, even though Animotion had many other great songs in their repertoire. Internal band pressures and outside pressure from record company executives to produce a hit in the same vein caused the band to go their separate ways. Singer-songwriter Bill Wadhams bounced around the Pacific Northwest for a bit, eventually landing in Portland, Oregon. It was in this bucolic woodsy setting that he raised a family with his wife Kate and began working as a graphic designer. At home, he seems relaxed and easy-going, a man clearly happy with where life has taken him. He proudly leads me to his computer to show me images of his son, who had been in Europe walking the runway in a fashion show.

Wadhams is still passionate about music and his songwriting is a constant creative outlet for him. He's put together a local band, Bill Wadhams & Friends, and also reunited with Animotion back in 2001. They had intended to put out some new music, but the timing wasn't right until a company in London signed them in 2015. They released *Raise Your Expectations* in 2017, which included a re-working of their song "Let Him Go."

Older and wiser, the band feels confident these days and it shows in the effortless way their sound comes together.

"I don't regret the choices I've made, and I'm happy to have the opportunity to write and play music today," says Wadhams.

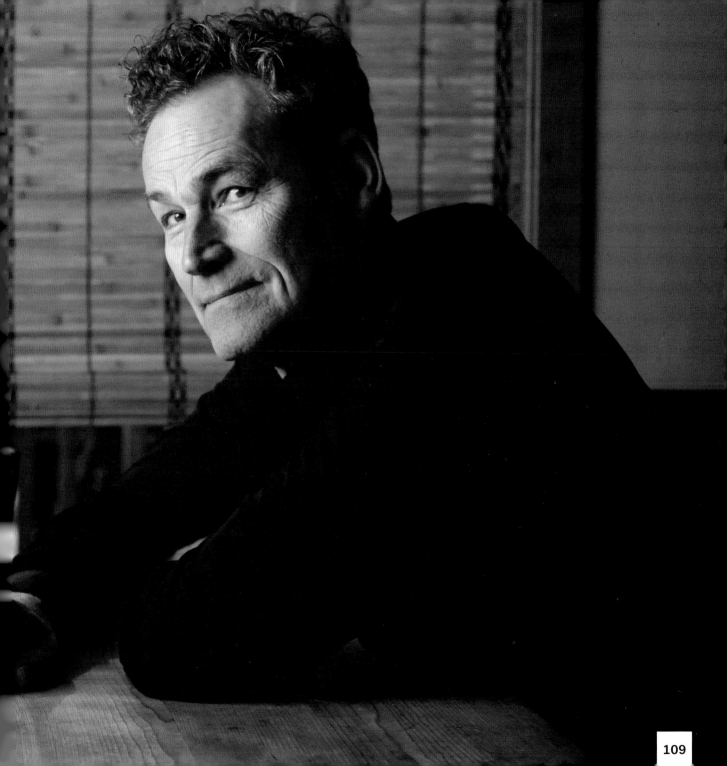

Kurt Neumann

The BoDeans may have had their biggest hit in the 90s with "Closer to Free," but it was the 80s when their star was really rising—even opening for U2 on some legs of their *Joshua Tree* tour in 1987. It was during this time that they developed a reputation as a great live band with a talent for creating big songs with catchy melodies. The path to this success all started with lead singer Kurt Neumann's transistor radio.

"My earliest influence was the AM radio and all the great magical music that was coming out of the small little transistor radio I had," says Neumann. "Late at night, I could pick up WLS out of Chicago and it just sounded like there was a magic place where all this beautiful music was happening and I wanted to find that place. Music was always a great escape for me."

The BoDeans still tour and have recently been doing more stripped down shows. "I wanted to play some smaller rooms. Quieter. More intimate. Playing with fewer musicians gives everybody a little more space to create. We've done the big loud rock festivals for so many years. Just wanted to be a little quieter for a while."

Neumann will definitely continue to create new music and share it with the band's fans.

"I think I was born with a drive to create. I always loved all creative endeavors. Music, art, building, just doing nothing, and thinking. Sometimes it feels like a curse. Being creative and trying to make a living is not the easiest task in the world. You're always trying to create something from nothing. And of course there's a lot of rejection involved. It's not like some jobs where someone asks you to do something and you do it and you get paid and then you put it away and go home. With creative, you never put it down."

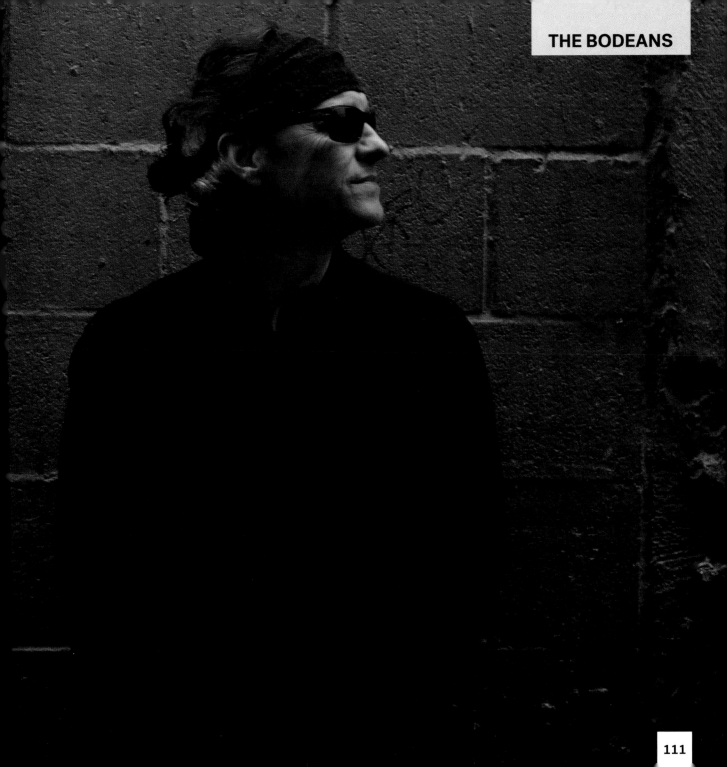

Laurie Sargent

Laurie Sargent was the powerful lead singer for the 80s band Face to Face (not to be confused with the 90s punk band Face to Face, which has no relation whatsoever to Sargent's band). They scored their biggest hit with 1984's "10-9-8" and also provided the music for the band Ellen Aim and The Attackers in the movie *Streets of Fire*. After the group disbanded, Sargent went on as a solo musician and as a member of the group The Twinemen, which featured members of Face to Face as well as Morphine.

Sargent retreated a bit from the limelight and became an organic farmer in Montana. Creatively, she turned to painting, but songs kept humming themselves into her head.

After a solo tour in 2014, Laurie found the passion for music again. She regularly tours these days and has funded new recordings through a crowdsourcing campaign.

Robyn Hitchcock

Rock's eccentric music man peeks out at the rain, shrugs his shoulders and says, "Seattle," proceeding to come out from the awning and into the drizzle. I had met him at a local music shop where he was filming a performance, and I was concerned about the rain and getting Robyn all wet. He shared my concern for maybe a second before bounding out into the drizzle with me.

Hitchcock got his start in the band The Soft Boys before going solo in 1981 with his album *Black Snake Diamond Role*. By the mid-80s, he had formed Robyn Hitchcock and the Egyptians and had several college radio hits, including "Balloon Man" and "Madonna of the Wasps." His songs are known for their eccentric humor and he tells me that they come from "the same place as my dreams. An internal reservoir that is fed from the steady drip of experience through the mountain of my life."

Hitchcock is still out there recording and touring, now from his home base in Nashville.

"When you're young you're probably more vivid and definite. As you get older you may become more subtle, which could make for dull rock 'n' roll. Rock artists all used to be young, as rock itself did. How sexy is a seventy-year-old writhing on stage? More than you might think, given the audience for the Stones!"

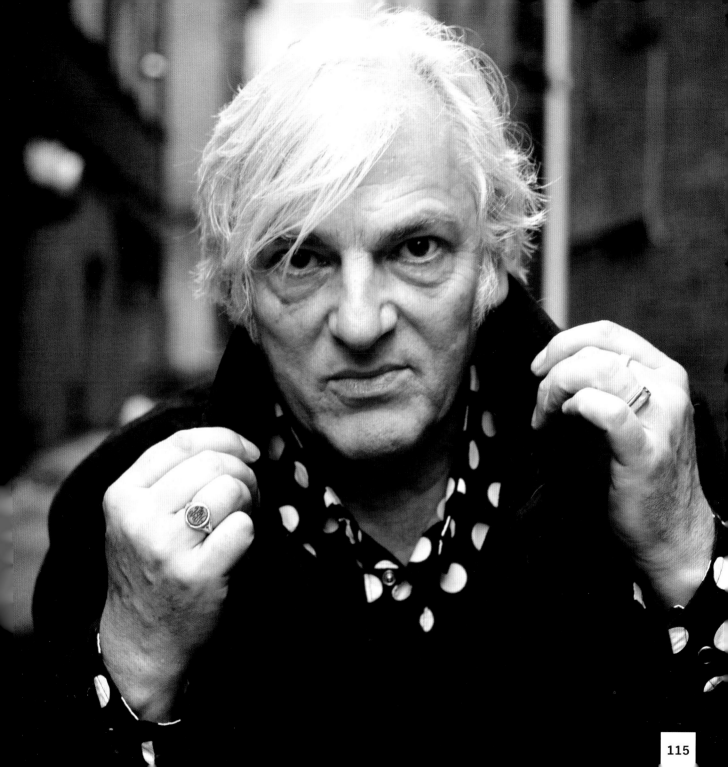

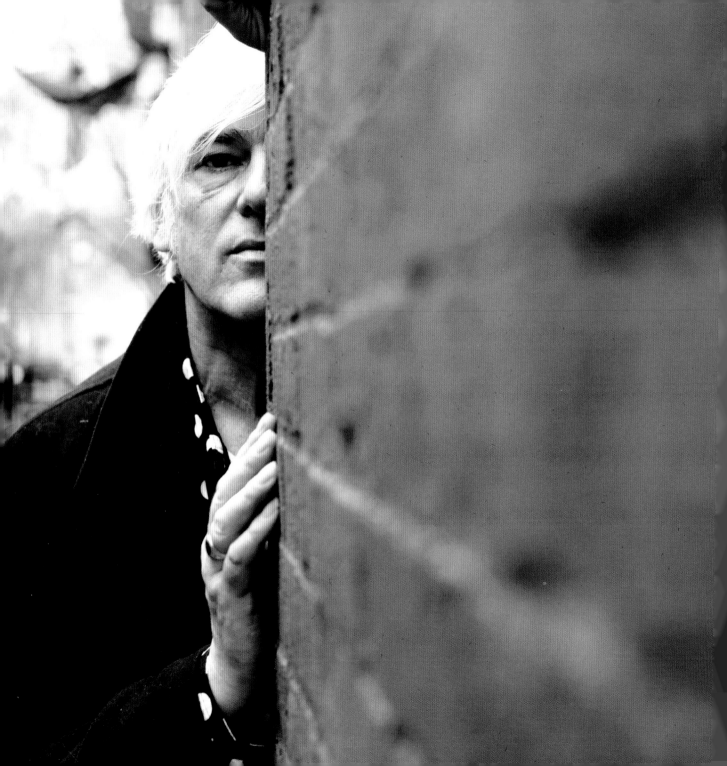

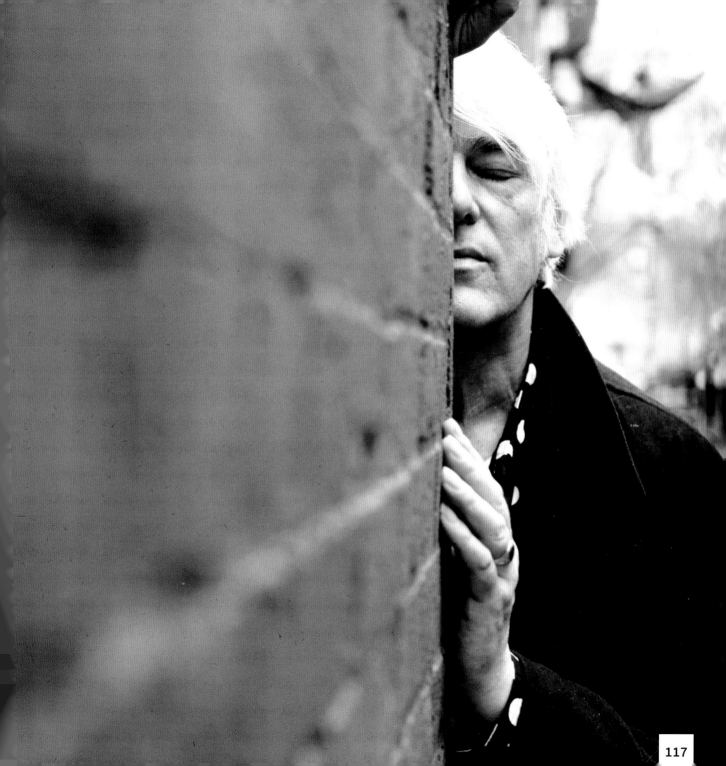

Paul Humphreys

"Don't be afraid of middle-aged men with synthesizers," shouts Orchestral Manoeuvres in the Dark's (OMD) singer, Andy McCluskey, from the stage. He had fallen ill at the end of this leg of the tour, but, as they say, the show must go on and McCluskey, along with singer/keyboardist Paul Humphreys, did not fail in their efforts to entertain the crowd.

Formed by the two friends in 1978, OMD quickly released a string of influential electronic singles: "Electricity," "Enola Gay," and "Tesla Girls"—edgy pop songs for the new decade. And then there was "If You Leave," their biggest hit. They actually wrote and recorded this song in only one day, after filmmaker John Hughes requested a new song for the final sequence of *Pretty in Pink*.

This massive commercial success led to band tension that eventually caused the duo to disband for a spell. During that time, McCluskey produced other artists and worked on solo music while Humphreys collaborated with Claudia Brücken (from Propaganda) on new, edgier music. OMD reformed in 2006 after they were asked to perform on a TV program in Germany, where they had always been popular.

Today, you can hear their influence all over the radio—from The Killers to MNDR to Robyn. They're still touring on their own, as well as with the 80s reunion tours, and creating innovative electronic music.

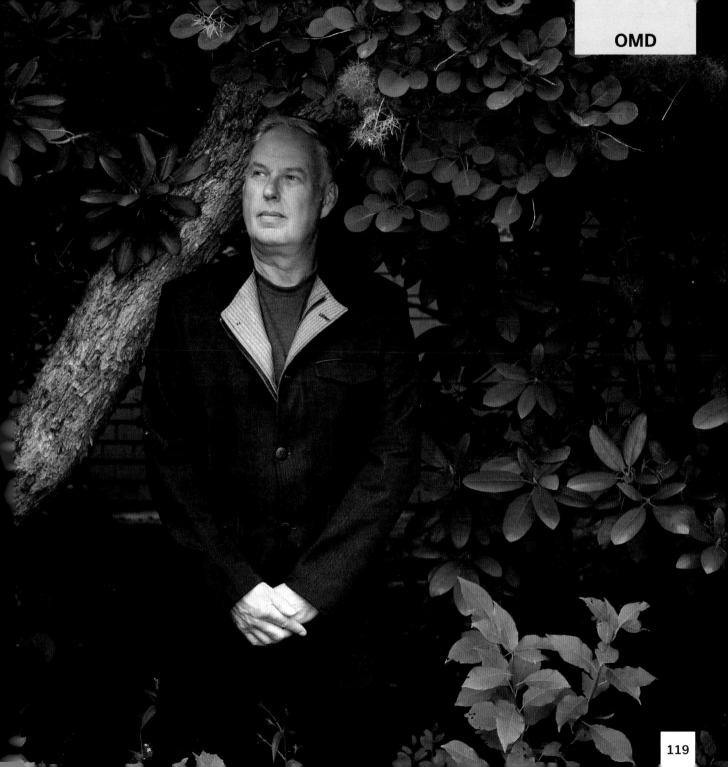

Kristin Hersh

"Mania" and "Dizzy" from the 1988 album *Hunkpapa* were my gateway drugs into the mangled world of Throwing Muses. I remember seeing them live around this time and being completely mesmerized by Kristin Hersh's eyes. She seemed to disappear into another world . . . it was as intense as their songs. I've seen Hersh perform recently and that disappearing act has not faded with time.

Kristin Hersh founded Throwing Muses when she was just fourteen years old. They bounced around New England clubs creating glorious noise alongside bands like The Pixies and The Lemonheads. Ultimately, they became the first American band signed to the influential 4AD label in the U.K.

Kristin still records and tours both as a solo artist and with her bands Throwing Muses and 50 Foot Wave. She's created a unique crowdfunding model to get these works funded—a subscription model in which her fans (whom she calls "Strange Angels") become stakeholders in her projects.

Hersh has also written what is, in my opinion, one of the best rock memoirs of all time. *Rat Girl*, released in 2010, outlines her struggles with bipolar disorder, delves into her unlikely friendship with classic film star Betty Hutton, and talks about the early days of Throwing Muses. She has also written a biography of her friend Vic Chesnutt titled *Don't Suck, Don't Die*.

I ask her about her musical idols. "I don't have any," she said. "People who play good music aren't responsible for it and people who play lousy music suck."

This sentiment is illuminated more in her memoir. She talks about her creative process and how she feels that her songs are just given to her. She tells me, "I believe now that songs just: are. They surround us with vivid textures and nutty rainbows. A musician turns them into music, but they aren't even necessarily sound."

Kristin's still swatting the songs away and I ask her if there's anything that can stop her from creating.

"I'm still looking for it."

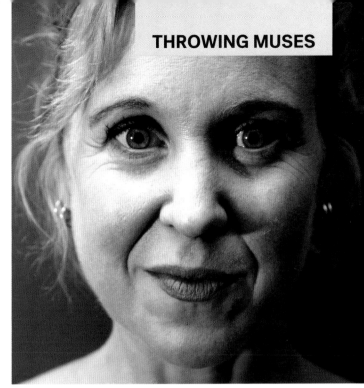
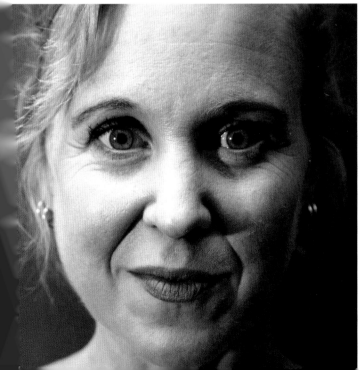
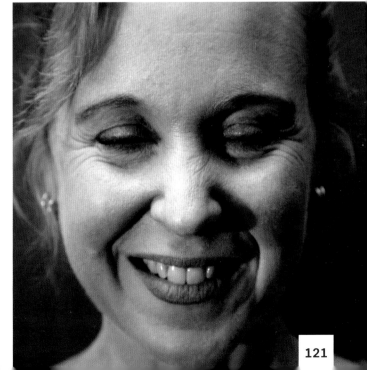

Paul Fishman

Re-Flex's biggest hit, "The Politics of Dancing," written by Paul Fishman, is one of those songs that is so perfectly representative of its era yet still manages to transcend the dated quality of many songs of its time.

"I grew up in the record industry," Paul tells me while sitting in his office's perfectly mid-century modern kitchen. His father was Jáck Fishman, who wrote Tom Jones' hit "Help Yourself," among other songs. His interest in creating music—electronic music in particular—happened early and he recorded his first project, a conceptual album titled *In Search of Ancient Gods*, when he was just nineteen. He began producing and working as a session player on other people's records. He met fellow musician Paul Baxter through a mutual friend and together they formed Re-Flex in the early 80s. By 1982, they were recording their debut album with Roxy Music producer John Punter. Two years later, they were opening for The Police on their final tour. That quick rise took its toll.

"We did a heavy period of touring and I kind of got fed up with it. I liked doing concerts but couldn't handle all the waste of a day. Your whole day was scheduled around this hour or hour-and-a-half performance and everything was geared towards that. And then you go to the next town and do the same set. I hate doing things in repetition like that. To do something that is an artistic thing, to just do it over and over and over again, seemed excruciating to me."

Today, Fishman is busy creating new music and was instrumental in starting Resonance FM, a noncommercial radio station that plays whatever a program's host wishes, twenty-four hours a day. "There's no control over the content beyond giving the producers of the show permission to go out and make a program. It has a broader range of music than any other station."

As for Re-Flex, the band never officially broke up. They recorded "Vibrate Generate" with original band member Roland Vaughn Kerridge before he passed away in February 2012.

In anticipation of Fishman's new solo work, which he's hoping to release in 2018, I ask him the inevitable question about whether or not electronic music is soulless.

"They clearly haven't heard what I'm working on at the moment!"

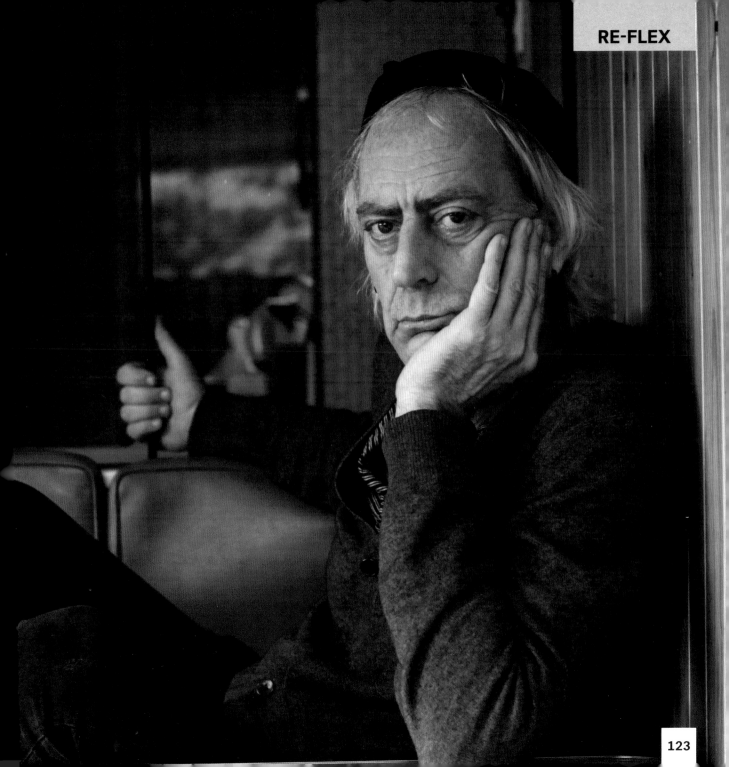

Baxter

Baxter was the distinctive lead singer for Re-Flex, bringing a David Bowie-esque vibe to Re-Flex's electronic grooves. Towards the end of the band's run, Baxter had relocated to Los Angeles with his then wife, yo-yoing between L.A. and London while working on the band's second album.

"There was some dubious record company stuff that had happened on the completion of the second album, *Humanication*, and we found ourselves going round and round in circles with record company people, and I was quite thankful I had made my home here," he tells me in his sunny L.A. backyard. "The four of us making the racket we made, which I'm very proud of, it would have been good to go out there and do more but we never did. It always seemed to be the wrong time or there wasn't enough interest from the other members of the band."

As the band went on hiatus, Baxter started working on solo material that was never released. He wasn't necessarily pleased with the sound or production of this material, and he felt it wasn't supported by his management team at the time. "There's some good songs there but I didn't feel particularly happy with the way that stuff turned out," he tells me.

He started working with other writers in the 90s and was working to help develop younger artists with record companies. Re-

cently, he's turned back to working on his own material.

"We'll see how that moves forward. I'm going to be working on stuff that I'll hopefully be able to get out soon. There's a lot of material and I have lots of ideas in my head. I think people will quite like it. It's not like I've overstayed my welcome! I've been fairly quiet since a long time ago."

Things came full circle when band members Paul Fishman and Baxter, along with drummer Roland ("Rolli") Vaughn Kerridge, worked on a final Re-Flex track titled "Vibrate Generate." The song came about after Roland fell ill. Paul was working to convince him to try doing music again, but Rolli had a hard time finding the inspiration. So Paul said to him, "how would you like to record one last Re-Flex track." It was meant to be "the ultimate Re-Flex track." They got Nick Launay to mix the track; Launay was the mutual friend that had introduced Baxter and Paul. Rolli passed away shortly after the track was completed.

I couldn't resist asking Baxter if Duran Duran had nicked the title of their hit song "The Reflex" from their band name and he chuckles and tells me, "Nick might have called the day before it was released and said, 'I'm really sorry, man!' But, let's leave that as an urban legend, my friend."

Baxter ends our conversation by saying, "If every project I do from this point forward in my life, I can have as much fun as I did with the lads in those early days, I'd be a happy man."

Steve Mack

That Petrol Emotion might not have been the biggest band of the 80s, but they garnered a solid fan base and much critical appreciation. The band was originally formed in London in 1984 by members of the then recently disbanded The Undertones and American singer Steve Mack. Mack had been living in London, working in a pizza restaurant when one of the waitresses asked if he knew anyone who could sing.

"I said, 'Yeah, me!' Before you know it I was in a band," Mack says. "And we got really popular really fast. I ended up staying in London for eleven years, ten of which I was in the band. They were magic times."

That Petrol Emotion's edgy and noisy style was able to break through with very little filter.

"We never had to compromise, because we had a strong manager who let us do what we wanted. But in retrospect, I wish he'd pushed us harder. We never toured enough, we didn't write enough songs, and we were arrogant enough to think that our fans would love everything we did. We learned the hard way that you're only as good as your last

record, and that recapturing the public's imagination is an incredibly difficult thing to do."

After a solid run, the band members had become disillusioned with the music industry and decided to call it quits in 1994. Today, Steve Mack lives in Seattle, working in technology and keeping busy raising his young son.

Since 2010, he's also been playing with a new band, Stag. "We're all men of a certain age who have played in bands all our lives," Mack says of Stag. "There's a certain freedom that comes with letting go of your ambitions and just letting the music take you where it wants to go. We play what we grew up on, 70s rock with strong melodies and choruses, through our present-day prism. It's equal parts serious and ridiculous, fun and fearless. And, ironically, we're getting more attention and airplay than any of us got with our former projects."

Mack talks about the end of That Petrol Emotion: "We should have kept going, and kept doing our thing. I still think we had two to three more albums in us. Who knows, maybe we could have pulled a Los Lobos and gotten wildly popular with our seventh or eighth album? But then I wouldn't have moved back [to Seattle], and wouldn't have experienced all the amazing things I've experienced in my life since. So I have no regrets. Life has been very good to me. And I've still got two to three more albums left in me!"

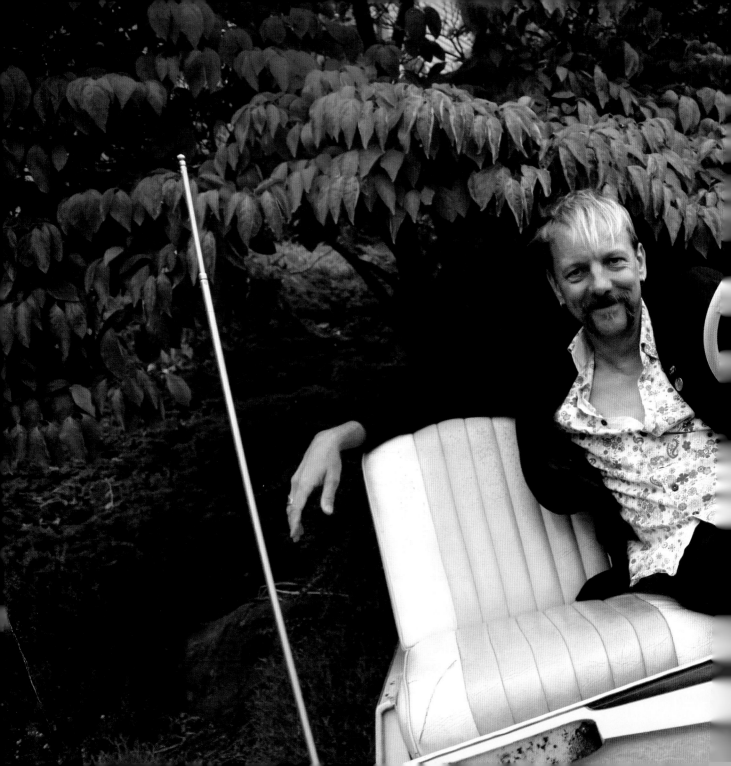

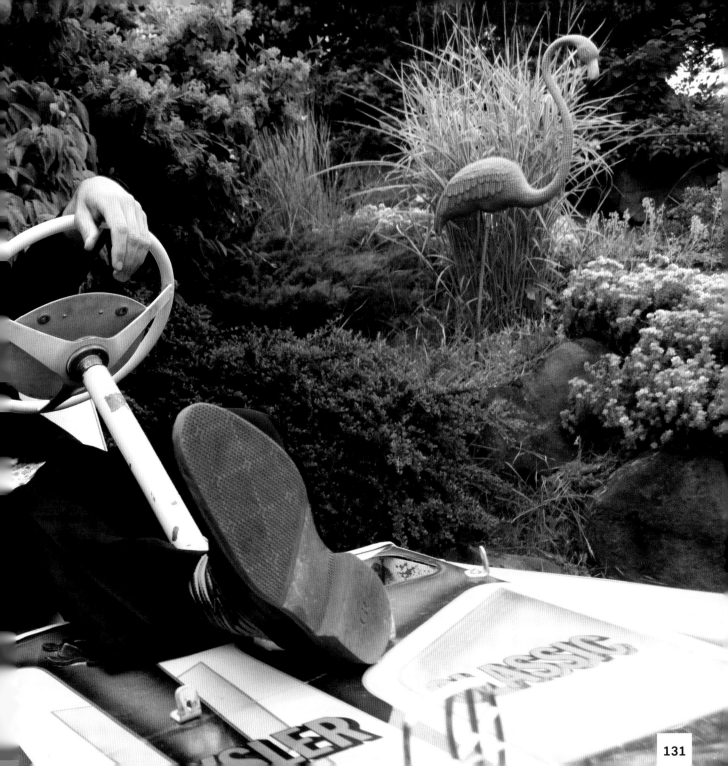

Tommy Heath

One of power pop's finest three minutes is Tommy Tutone's "867-5309/Jenny" from 1981. And, now that I've mentioned it, that classic chorus will be bouncing around your head for the rest of the day! In real life, there is no Tommy Tutone. There is, however, a Tommy Heath—the lead singer of the band who currently resides in Portland, Oregon.

After the massive success of "Jenny," Heath released music under the Tommy Tutone name but nothing hit as hard as that initial rush of success.

As he always thought of himself as "a country songwriter," he spent a few years in Nashville before moving to the Pacific Northwest to become a computer programmer. He still gigs around town and with many of the 80s tours that crisscross the country. He is also recording new music and, in 2017, released a new single, "Little Red Book."

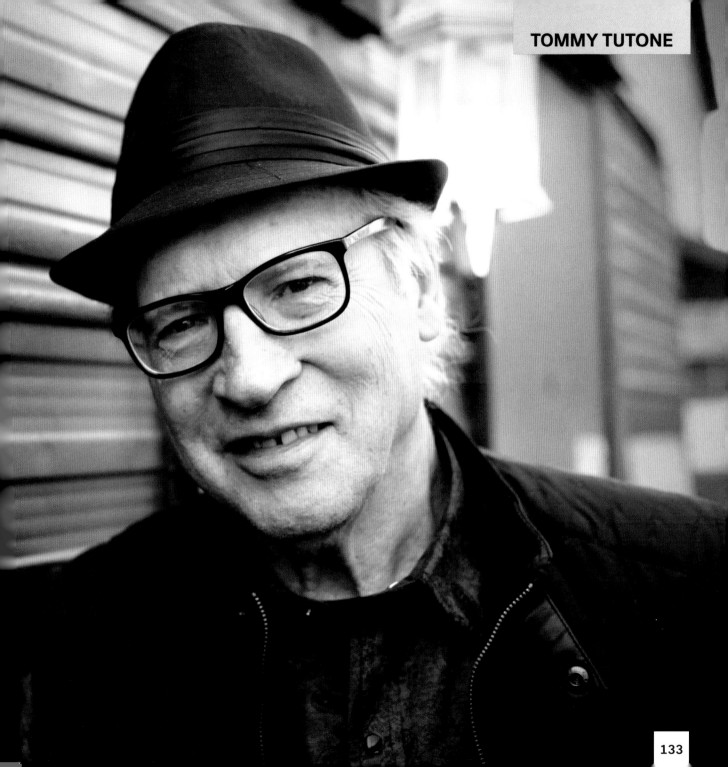

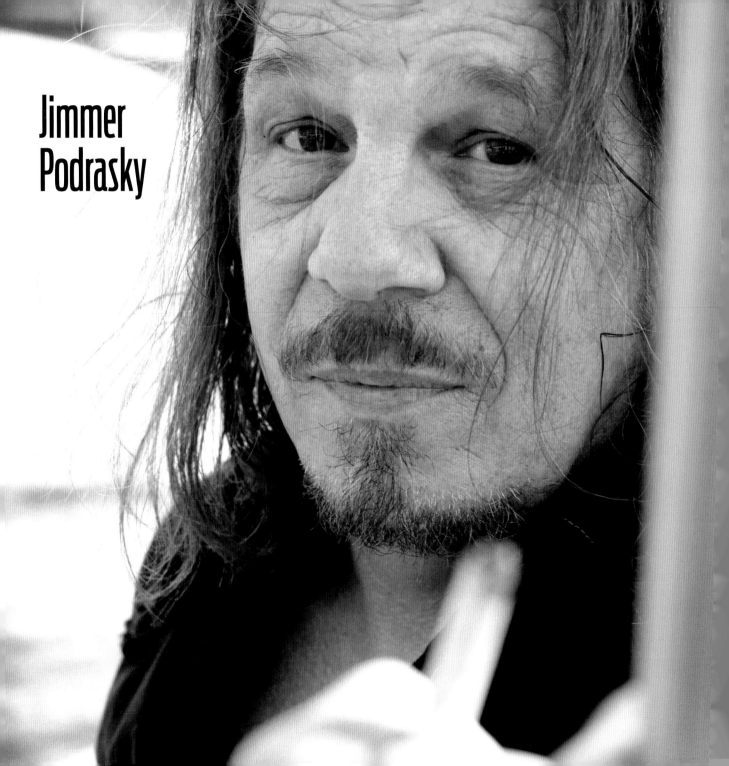

Jimmer
Podrasky

After seeing *Pretty in Pink*, my friends and I all wanted the soundtrack. But, when we got it, we realized that two of the best songs were missing. The two songs from The Rave-Ups, "Positively Lost Me" and "Rave-Up/Shut-Up," were conspicuously absent.

"Our lives today would be different if we had made it on the soundtrack," singer Jimmer Podrasky tells me. At the time, all four members of the band were working in the mail room of A&M Records, the label that eventually released the soundtrack. It seems like record company politics played a huge role in keeping them from being on the soundtrack.

Jimmer has a bit of a love-hate relationship with the song "Positively Lost Me," telling me, "As a songwriter, I kind of hate it because it's the only song people ever bring up." He laughs and continues, "You do know I've written other songs?"

Just as the band was beginning to take off, Jimmer left to raise his son. "It wasn't because I didn't love being in the band," he tells me. "I just couldn't really be in a rock and roll band and be a dad at the same time." He found a job reading scripts for William Morris, which afforded him the flexibility to be with his son.

But, as often happens to many of us, life got pretty tough and being the former lead singer of Molly Ringwald's once favorite band offered no protection. In recent years, Jimmer

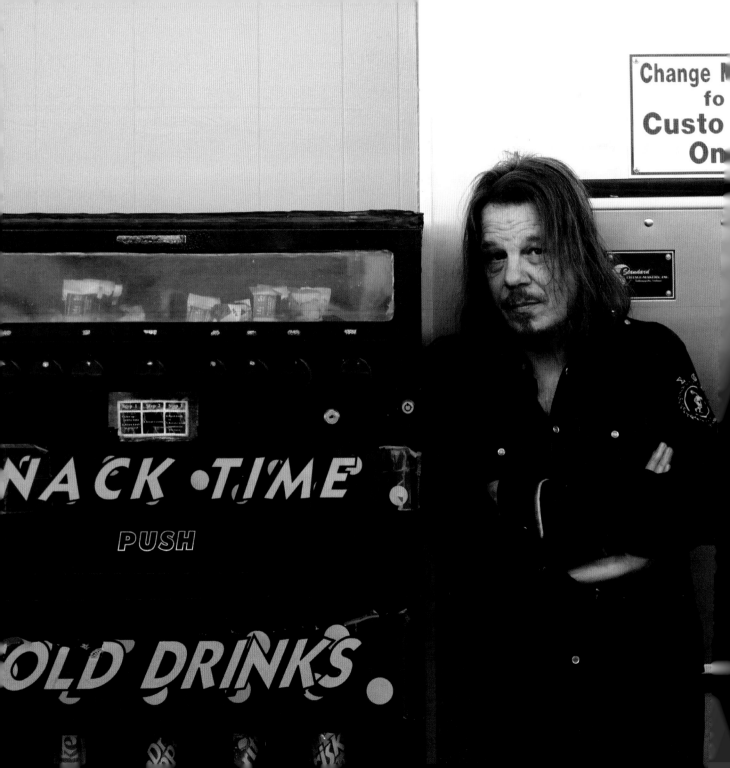

lost his job with William Morris and struggled with finding new work. His son had also moved away and Jimmer felt broken, both physically and emotionally. A phone call to his cousin resulted in the authorities being called and Jimmer being detained for a seventy-two-hour hold out of concern for his mental health.

"At the time, I was one of millions of people who were victims of the Great Recession. Everybody was downsizing and they didn't need people like me anymore."

After reaching this low point, Jimmer found a new community of collaborators to work with. He let producer Mitch Marine come in to help craft his two solo albums and Ed Sikov, an old childhood friend, stepped back into his life to help finance the recordings. "I don't know what I would have done without him," he tells me. "It's impossible to talk about getting my life back together, not only in a musical sense, but in a personal sense, without talking about Ed. It allowed me to get back to the one thing in my life I could do well."

Today, you can hear the optimism in his voice as he talks about his latest projects, his music, his duet with Syd Straw, and the work he's still excited to do.

Wire

Wire, the influential post-punk auteurs, refuse to play it safe and rest on nostalgia. Their U.K. press person has said that the band is about "40 years of not looking back." Vocalist/guitarist/songwriter Colin Newman thinks this makes a lot of sense. "I'm not interested in trying to recapture some kind of previous age or something like that," he says. "There are a lot of people who are involved with music who've been around for a while who get kind of stuck in a rut. Basically, being about what they were in the past. You can't criticize someone if this is how they make a living. But, this is supposed to be art and we should be making a bit more of an effort to do something original."

Today, outside of Wire projects, most everybody in the band has other things going on musically. Colin and his wife, Malka Spigel, have been running a label called swim~ since the early 90s. They've released a mostly electronic record called *Immersion*, and they're working on a follow-up. In 2016, Newman re-released his first three solo records, which he described as "an interesting exercise in 'non-nostalgia.' I just wanted to make them available. I put them out in such a way that the fans would like them—the CDs were doubles and the first one was the original album and the second was everything else, including loads of stuff that wasn't released."

Speaking of nostalgia, Newman talks about getting the band's new work pressed to vinyl—the ultimate in nostalgia. I ask about why he sees this resurgence of vinyl and it turns into a discussion on analog versus digital. He tells me, "Is shooting on film *better* than shooting digital? It's just different. You get a different result. You can fake up film in lots of different digital ways and you might end up shooting on film and then scanning it and working on it in Photoshop. It's just a different way of going around that. There's a fixation among a certain set of people that it has to be on vinyl—it's just to do with the method of consumption and it's a kind of pushing back against the ease of digital. You can stream all your music on your phone and never own anything and that's a very different culture to the record shop culture of going in and finding out what's hip by taking it home. But, the music is the same. I get asked this all the time, don't I look down on people who consume our music on Spotify? No way! It's just a different person, it's a different cultural expectation in how to listen to music." He acknowledges the payment issue and hopes

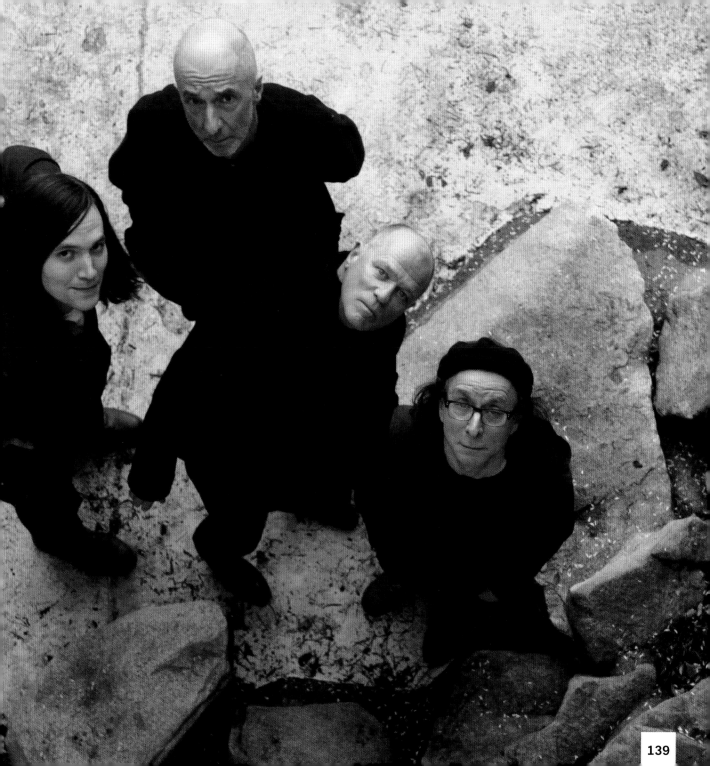

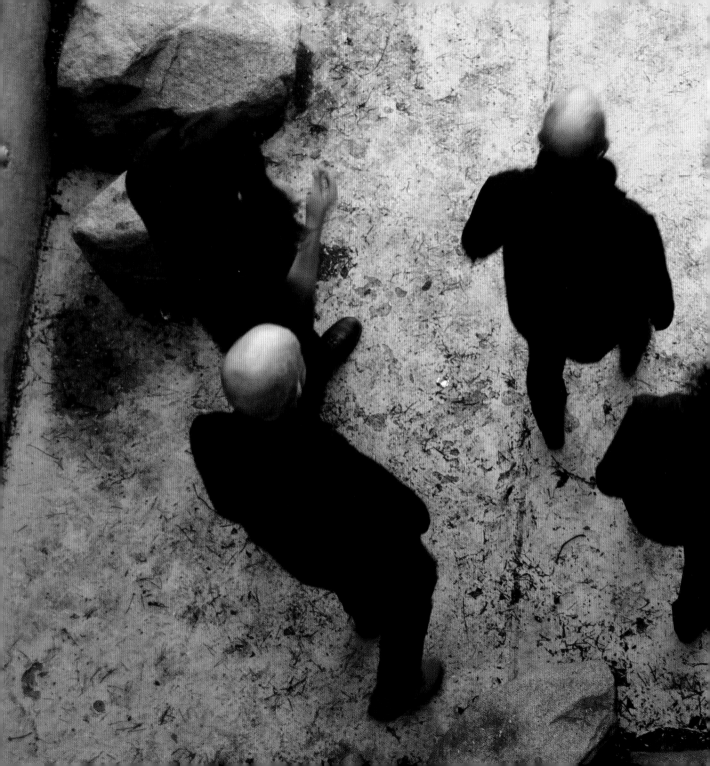

that payments will increase in time. "In order for people to continue to make music, there has to be an income."

Colin likes to have his hand in multiple projects: "Why would I do other projects besides Wire, things people might not have heard of? Simply because it's supposed to be art and you're trying to be a rounded person and, as an artist, sometimes one project doesn't tick every box." There will be more touring with Wire, more studio time with his wife and other collaborators, lots of behind-the-scenes work at his labels, swim~ and Pink Flag.

And, through it all, he'll continue to look to the future. "All attempts at trying to re-do what you did before are doomed to failure. You're not the same person anymore and you can't re-create what you did in the past and any attempt to do it would reveal all of the weaknesses."

Acknowledgments

Creating this book has been like writing one giant love letter to the 80s. I traveled to three countries and all four corners of the United States. I rode trains, planes, and automobiles to get there. I suffered through one kidney stone, created many playlists to psych me up, and discovered some long lost songs to add to my collection. Along the way I met and even befriended some of my teenage faves—it was hard not to imagine what my sixteen-year old self would be thinking if he could see what the future held for him.

I consider each and every artist who agreed to participate in this book a collaborator. They allowed me access to their homes and lives for a few brief moments, and shared their stories and experiences with me. Without them and their spirit of generosity, this book would not be possible, and I cannot thank them enough for their participation and trust.

In addition, I want to thank my husband, Sam, for encouraging me along the way, for picking me up when I felt down about the book's prospects, for holding down the fort while I was traveling to meet artists, and for constantly being my rock in this book and in life.

There have been numerous other people without whose help this book would not be possible. Kathy Casey, Emily Freidenrich, and Lori Hinton for teaching me how to write a book proposal, offering suggestions, and being generally enthusiastic about the project.

A big thank you to Allison Kline for designing a kick-ass mock-up of the book for publishers, for being an occasional travel partner, and for taking me to the ER in London while we were there working on this project. Jen Hausmann, Melissa Serdy, Tom Wear, and Jill Davies Wear for loaning me their prized concert tickets for a spread in this book, as I've managed to lose all of mine—and for always being enthusiastic! Added bonus to Melissa who ran over to take one very last-minute look through the final images for me. Dave Holmes, for agreeing to write a foreword that so perfectly sets the tone for the rest of the book and made me cry a little. Diane Wehanu, who was my high school photography teacher in the 80s and gave me a purpose by encouraging and teaching me the art of photography. I'll always remember her looking at one of my prints after I failed miserably at even loading my cheap 35mm camera: "Well, look at that! When did you learn to be a photographer?" And, of course, to Jesse Marth at Schiffer Publishing who saw the same potential as I did in this project and agreed to take it on.

©Rafael Soldi

MIKE HIPPLE is a freelance photographer based in Seattle, Washington, and has worked with clients ranging from *US News and World Report* to Microsoft to Philips Technology to *Sunset* Magazine. A graduate of the Savannah College of Art and Design in Savannah, Georgia, he has won numerous awards for his work. For more, visit www.hipphoto.com.

H.J. KAISER ARENA

10 TEN STREET

A28SEP8

FIELD SEAT
SEC 225 ROW N SEAT 5
ADMIT ONE THIS DATE ONLY
PacificConcerts & Pepsi PRESENT
DAVID BOWIE
★★★★★ THE GLASS SPIDER TOUR ★★★★★
Civic Stadium

MICHELOB PR
ROBYN HITCH
& THE EG YP
THE RITZ, 119 E
RTZ1226 16 YRS AND OLDER
TUES SEPT 2

BILL GRAHAM
INX 15SEP8
NO CAMERA/BOT&CAN/ALCOH
S.F. CIVIC AUDITORIUM

GP329 GA GEN. ADM.
GA SECTION/AISLE
$17.50 PRICE
2.00
GEN. ADM
1X

MEDIA ONE
S AN EVENING
THE CURE
TLE CENTER ARENA
LY 10, 1987 8:00P

BAL2 M 12 $17.50
SEC ROW SEAT ADULT
RIGHT CENTR
GP&MILLER GENUINE DRAFT
CROWDED HOUSE
NO CAMERAS/BOT&CAN/ALCOH
WARFIELD THEATRE
82 MARKET STREET

AISLE 5 D S 7
SEC ROW SEAT
ORCHESTRA HO
ADMIT ONE THIS DATE ONLY
NOV

GEN ADM ADULT ADMISSION
ROW/BOX SEAT 18.50
ADM
GRAHAM F

GEN ADM
RAIN OR SHINE
BILL GRAHAM PRESENTS
10,000 MANIACS
IN ASSOC. W/CAL PERFS

SG0410 K 29 5
EVENT CODE SECTION/BOX ROW
21.CC TOWER C GATE 3
CC2.50 5TH AVE 31ST
MADISON SQU
G.A.
CA 1X
GEN ADM
RTZ1726

RZ1113 G.A. GE
EVENT CODE SECTION/BOX
14.50 GENERAL A
ST. PAUL
THE RITZ
DOORS 7:30
16 YRS AND

RZ0970 G
EVENT CODE SECTION/BOX
12.00 GEN
PRICE & ALL TAXES INCL.
G.A.
SECTION/BOX
CA 1X TH
GEN ADM

IRVING PLAZA
IRVING PLACE N.Y.C.
WLIR PRESENTS
BIG AUDIO DYNAMITE
DOORS OPEN AT 9:
169502RE0806 3

DATE/EVENT CODE
04223 10 G.A.
ENTER 9:00P

SEC LOC
RAINCHECK

THE
PRESENTED BY
BURNING RIVER PROD
THURS. MAY 26, 198
DOORS OPEN AT 8:00

ADM. SEAT 62
DATE
988

SMOKING IS PROHIBITED
IN SEATING AREA

TTING FACTORY PRESENTS
ALEX CHILTON
12-219-3055
MAY 29 1988
UN 29 1988 9:00 PM
NO EXCHANGES
$10.00
ROW SEAT

square garden
7th Ave 31st at 33rd Sts.
RE GARDEN
31-33 STS.
7E A 4
2/3 21XXXX
GATE 10
7E

SEC ROW SEAT 26
GEN. ADM